PLAYERS AND THEIR PETS

Players and Their Pets

GAMING COMMUNITIES FROM BETA TO SUNSET

Mia Consalvo and Jason Begy

University of Minnesota Press
Minneapolis
London

Portions of chapter 1 were previously published as Jason Begy and Mia Consalvo, "Achievements, Motivations, and Rewards in *Faunasphere,*" *Game Studies: The International Journal of Computer Game Research* 11, no. 1 (February 2011).

Copyright 2015 by the Regents of the University of Minnesota

Published by the University of Minnesota Press
111 Third Avenue South, Suite 290
Minneapolis, MN 55401-2520
http://www.upress.umn.edu

Library of Congress Cataloging-in-Publication Data
Consalvo, Mia.
 Players and their pets : gaming communities from beta to sunset / Mia Consalvo and Jason Begy.
 Includes bibliographical references and index.
 ISBN 978-0-8166-8982-8 (hc : alk. paper)
 ISBN 978-0-8166-8983-5 (pb : alk. paper)
 1. Video games—Social aspects. 2. Computer games—Social aspects.
3. Computer networks—Social aspects. 4. Internet—Social aspects.
5. Group identity. I. Title.

 GV1469.34.S52C66 2014
 794.8—dc23 2014025340

Printed in the United States of America on acid-free paper

The University of Minnesota is an equal-opportunity educator and employer.

21 20 19 18 17 16 15 10 9 8 7 6 5 4 3 2 1

CONTENTS

ACKNOWLEDGMENTS

Many people helped us during this project, offering feedback on our work, inspiring us with new ideas, and providing valuable information. Perhaps the first people we should thank are the players of *Faunasphere*. Without them we would not have a project at all, and their generosity and willingness to share their thoughts and ideas—even when they were in emotional turmoil—is something for which we will always remain grateful. That includes everyone who completed our initial survey, those whom we interviewed after the game's close, and other players who offered their help and ideas on the game's forums as well as via their Facebook group. Likewise we also thank the staff at Big Fish who expressed initial interest in this project and helped us set up the survey and provided valuable contextual information about the game and its players.

We thank our friends and colleagues at MIT and Concordia University who supported us through the research and writing of this book. They asked us insightful questions and commented carefully and extensively on early drafts of chapters, encouraging us to push our work further and see how it had important implications for game studies and particularly for our understandings of massively multiplayer online games and casual games. The people at the Singapore-MIT GAMBIT Game Lab provided ongoing support, encouragement, and endless feedback, and with our move to Concordia University in Montreal we found a new group of supportive colleagues at the TAG center who were only too happy to continue the job of pushing us and our ideas forward. During the writing of the book, we presented pieces of it in numerous places, and dozens of people offered support and good ideas for how to develop our arguments. To all of you, a big thank you!

Mia would like to thank too many people to list here individually. She wants to be certain to express her gratitude to her family, who learned far more about a game that no longer exists than they ever expected to. John, Jasper, and Sam are offered a big thank you for putting up with the

writing of this book over several more years than expected and for always offering fresh perspectives and new ideas to jump-start stalled progress.

Jason would like to thank everyone at the MIT Game Lab for their continued input and support, especially Philip Tan, who made this all possible. Thanks as well to Owen Macindoe and Sophie Mackey for being there at the end—their fauna may have been the shortest lived, but I know they are missed nonetheless.

A Different Kind of World

It was my life away from life.

—BADGERS TTQ

First Encounters

Odds are you've never heard of *Faunasphere*, and in this, you wouldn't be unusual. *Faunasphere* was a massively multiplayer online game (MMOG)—a genre dominated by games such as *World of Warcraft* and *EverQuest*. Unlike these games, however, *Faunasphere* did not have hundreds of thousands, or even tens of thousands, of players. Whereas *World of Warcraft* has been running (at the time of this writing) for about ten years, and *EverQuest* for fourteen, Faunasphere was open to the public for less than two years. The game was ultimately closed because its developer, Big Fish Games, considered it to be "economically unsustainable." Whatever the true meaning of this phrase, it seems likely that the game was not generating enough money. In many respects, *Faunasphere* was barely a ripple in the pond of online computer games. Yet what did its players think of the game? Becca said that "it was magical and I still miss it." Beatrice told us, "I have no family and no pets. *Faunasphere* helped fill those painful gaps in my life." And after it closed, Jackie reported, "I am still looking for something like *Faunasphere* . . . but it's still unique in all the world."

Clearly it was incredibly important to its players, many of whom fell in love with it. Furthermore, *Faunasphere* was also very different from the games that defined, and continue to define, what MMOGs can be. It put players into a different kind of world, one that did not build on common fantasy or science fiction tropes, and tasked those players with caring for groups of friendly and playful animals. Throughout this book, we argue

FIGURE 1. The game screen.

that these differences make *Faunasphere* a critically important object of study, even more so than large, commercially successful games that too often have shaped game studies discourse by becoming implicit baselines for analysis. This book tells the story of *Faunasphere* and its players and along the way shows how outliers like *Faunasphere* offer challenges to prior work that relies too heavily on narrow conceptions of just what the domain of "videogames" entails.

We first discovered *Faunasphere* in late 2009 and were immediately fascinated by the game and its players. Here was a bright and colorful online world, populated by players who, contrary to our expectations of online gamers, were exceedingly welcoming, friendly, and helpful. The developer, Big Fish Games (BFG), was at the time a highly successful developer and publisher of "casual games"—typically short, simple-to-play games available on the web. Big Fish had been particularly successful with their "hidden object" games, such as *Mystery Case Files*, and so *Faunasphere* represented a new direction for the company. At first glance, the game had many of the trappings of a typical casual game: a brightly

colored world populated by happy animals, all explained to the player by very excited and friendly human characters. Such tropes were common in casual games, which at the time were trending toward high production values built on simple, tried-and-true game mechanics such as "match-3" or "hidden object." So when we first dove into the world, we expected the gameplay to fit neatly into established patterns. But this was not to be the case, and it turned out that *Faunasphere*'s inviting surface hid a game of surprising depth and complexity. We also discovered that despite these factors, and an unexpectedly sharp learning curve, much of the player community was derived from Big Fish Game's existing customer base.

Faunasphere ran from 2009 to 2011, during which time it occupied an unusual space in the digital games market. Set in a persistent online world, *Faunasphere* tasked players with hatching and caring for a group of cute cartoon animals known as "fauna." Using their fauna, players explored a vast world where they could pick fruit and dig for roots, participate in games and contests with other players, zap pollution, build and customize their own private space, breed and raise entirely new fauna, and chat with other players. Although the game built up an extremely dedicated player base, it closed after less than two years of operation. For many players, this was the only persistent online game they had ever played, and the community's reaction to the closing was a profound mix of anger and sadness.

Thus *Faunasphere* was an unlikely hybrid of two genres—casual games and MMOGs—that could not, on the surface, be more different. "Casual games" are typically downloadable or browser-based games that are shorter and simpler than most other videogames (particularly big-budget titles for the PC and game consoles), have positive themes,[1] and are predominantly played by middle-aged women.[2] MMOGs, on the other hand, are often extremely long (in that they are designed to be played indefinitely) and complex, with gameplay focused on combat. Demographically, MMOGs have traditionally been dominated by male players, although many claim a small but strongly dedicated female contingent.[3] Given such significant differences between these two genres, we were surprised not only by *Faunasphere*'s existence but by the fact that it had been developed by a well-known publisher and developer of casual games, Big Fish Games. Even before we had a chance to start playing, the game raised many questions for us. Who was the audience? Who was playing, and why this game? How had Big Fish Games merged these two genres?

As we began to play the game more frequently and read the forums, answers to these questions started to suggest themselves. It became clear that the players had mostly come from playing casual games and, despite

the complexity of *Faunasphere*, were eagerly working together to understand the game's depths. We also realized that Big Fish Games's clever mash-up of game mechanics, MMOG conventions, and a largely colorful and positive fictional world turned on its head traditional ways of approaching how we study and understand virtual worlds. *Faunasphere* had experience points and levels but lacked other tropes such as humanoid avatars and skill trees. Players were asked to care for animals and rid the world of pollution; there was no evil to defeat or realms to conquer. By abandoning the traditional fantasy tropes that are near ubiquitous in MMOGs, *Faunasphere* showed us (ironically) how important fiction[4] has become in determining how game scholars understand the ludic nature of MMOGs and their players. Following a discussion with the game's developers, who were eager to learn more about the player base in their new game, we decided to undertake a study of the space and its players.[5] Thus we turned to a more systematic study of this game, with an eye toward seeing how a casual MMOG might challenge current theories about MMOGs, casual games, and those who play them.

New Approaches to MMOG and Casual Game Studies

Some of the earliest writing and theorization in the field of game studies has drawn from research on MMOGs such as *Habitat*, *Ultima Online*, and *EverQuest*, which themselves were influenced by work on textual multiuser dungeons such as *LambdaMOO* and fantasy-themed, *Dungeons & Dragons*–style hack-and-slash games. That early work provided foundations for understanding how players interacted with one another in shared spaces, how fantasy as a genre shaped those contexts, and how the player–avatar relationship might work.[6]

In her study of online play communities, Celia Pearce makes a distinction between virtual worlds that are "paidiaic" and "ludic." These terms are adapted from Roger Callois's terms for games ("ludus") and open-ended play ("paidia"). Pearce says that "the primary distinction is that ludic worlds have a formal structure of objectives and a set of constraints that dictate how those objectives might be met, whereas paidiaic worlds provide players with a range of activities and options for social interaction."[7] Ludic worlds are those most likely to be called games, such as *World of Warcraft* or *EVE Online*, as they tend to feature directed activity toward a specified goal. Paidiaic worlds are those "in which players engage in open-ended, unstructured, creative play." Paidiaic worlds frequently feature affordances for user-generated content, such as in *Second Life* or *There.com*.

Pearce notes that most MMOGs will support both types of play but tend to emphasize one or the other. *Faunasphere* was primarily a ludic world in that the game structured play through goals, raffles, breeding, and so on. While there was room for players to define their own goals, the game was designed so that players could only make progress by following the in-game goals. For example, by completing goals, players could gain access to additional game world areas such as the Frozen Village and the Swamp World, which could only be entered by a fauna that had a particular gene ("coldproof" or "heatproof"). By completing a sequence of goals, players could earn an item that would give this gene to one of their existing fauna, allowing it to enter these parts of the world. This gene would then be passed to the fauna's offspring.

Faunasphere did have some paidiaic elements as well, such as the spheres, which were private spaces allotted to individual users. However, these spaces were created using building blocks provided by the game and decorated with objects similarly obtained. Creation was not at the level of detail seen in the paidiaic worlds mentioned before. Further, because all the objects used in creating a sphere were provided by Big Fish Games, there was a consistent art style across the game world and through all the user-generated spheres. Interestingly, spheres also supported what was likely the most common form of paidiaic play: hide-and-seek games created and performed by the players themselves, of their own initiative.

Despite such differences, key concepts and practices continue to be relevant across both types of spaces (paidiaic and ludic), including studies of player communities, avatars and identity, and the troublesome nature of online/offline distinctions. Yet even as we have seen more nuanced and sophisticated theorization of those activities as new spaces have emerged (and older ones have been shuttered), there has been a homogenization of imagination among game studies theorists about how to treat such spaces and those who play within them.

Certainly this is a function of the overwhelming dominance in the current market of fantasy-themed MMOGs, with *World of Warcraft* functioning as the central driver of relevant research. But even (the little) research done on sci-fi- or alternative-themed worlds such as *EVE Online* or *Star Wars Galaxies* perpetuates key assumptions concerning how to study and understand MMOGs and their players that have gone largely unchallenged by researchers in this area. Worse still, much of that work has codified "what we know" about online play into oversimplified assumptions about player–avatar relations, how women (and men) "prefer" to play, and how we should study player interests, styles, and

actions. That thinking is so entrenched that taxonomies for understanding player activities online include categorical assumptions about what they do based on fictional premises that may or may not carry over from one space to the next. For example, Yee's famous motivation measures for online gameplay rely on fiction-centric measures such as "How important is it to you that your character's armor / outfit matches in color and style?" or ask how important the following activities are for the player in question: "being part of a serious, raid/loot-oriented guild" or "trying out new roles and personalities with your characters."[8] These activities are simply not possible in all MMOGs.

In a similar vein, studies of social and casual games have stressed the predominance of older women as active players but have mostly looked at the phenomenon of gameplay in functional terms—how long individuals play such games, what kind of games they prefer, and what led them to the activity.[9] There has been little or no work that attempts to explore a wider community of such players, or how the platforms themselves—such as Facebook—work to strongly shape preferences for and patterns of play.

But rather than continue to rehearse findings about players of MMOGs or casual games in isolation, we prefer to turn to *Faunasphere* itself, to give a better sense of how the game worked and what players could do within the space and how those activities differed or were similar to more traditional games and game studies findings. In doing so, we point to how the game resembled MMOGs in particular ways—such as the inclusion of certain mechanics—as well as how it also drew from casual game design in order to seem familiar to its original player base.

All about *Faunasphere*

Although we offer more detailed information about *Faunasphere* in the Appendix, we feel it's necessary to offer at least a basic description of the game here in order for readers to understand why the game felt so different from traditional MMOGs as well as single-player casual games. Doing so also allows us to point to how the game's design—in terms of both its fiction and its game mechanics—created a very different sort of online game for those who chose to play it.

In the world of *Faunasphere*, players were caretakers, and their job was to raise diverse types of fauna. Players began the game with one fauna, which the player used to zap cube-like entities described as pollution, rather than kill monsters in the game. Each zapped cube yielded money, experience points (XP), and items. Once a certain level of XP was reached,

the fauna would gain a level and lay an egg. Players could level a fauna to a maximum of twenty through zapping pollution as well as completing various goals ("quests," in MMOG terms) in the game world. The eggs that players collected could be traded among players, as well as purchased and sold. Eggs allowed players to breed new and different types of fauna, and breeding was designed as a core activity in the game.

Players could also engage in many other activities in the game, such as decorating their personal faunasphere (which we will refer to as a "sphere" in order to avoid confusion) and participating in raffles and other community events. Each *Faunasphere* account included one "sphere," which served as a customizable home for all the account owner's fauna. Players had a wide variety of choices when building their sphere, and there were frequent contests for the best-designed spheres. Players also created their own community events, including playing hide-and-seek in one another's spheres and having parades in public spaces to show off new or unusual fauna.

Faunasphere drew inspiration from MMOGs in several ways. The most obvious example was the nature of the game world: Play took place in a persistent, online space to which all players were connected simultaneously. Players would choose one of their fauna to use as an "avatar," roughly analogous to the "characters" used in more traditional MMOGs. However, fauna were not meant to "represent" the player controlling it; there was no "role playing" in the typical sense. Fauna and their caretakers were always presented as distinct entities. Part of this was in the language: Players were always referred to as caretakers, both in the game and on the official forums. While this will be fully discussed in chapter 5, the distinction was a defining attribute of *Faunasphere* and had many ramifications.

That the world was online meant that a play session could potentially involve many other players, and it was possible to chat via text and trade items. Players also had "friend lists" to which they could add other users, which would show what friends were online and also allowed a player to instantly "jump" to a friend's current location. Even by the standards of the time, the social features of *Faunasphere* were simplistic. There was no voice chat, no alerts when friends signed off or on, no chat channels, and no party or grouping mechanics. Whether this was due to resource issues or the relative lack of technical savvy among *Faunasphere*'s users (more on this later) is unknown.

Another convention adopted from MMOGs was that of "goals," which were similar to the "quests" found in countless other games. In each region of the world, there was a "goal station," where the player could go to be given tasks to complete. Goals, like inventories, were account-based, so

a player could switch fauna midgoal. Goals were typically of the "find a number of items and bring them back here" variety, with a few notable exceptions. Perhaps the most (in)famous was "Monty," a pollution monster that players had to defeat and the closest thing to a boss battle that *Faunasphere* had to offer. In typical MMOG fashion, completing goals gave rewards in experience points, lux (money), and sometimes items. The Monty goal was a popular way to earn XP and lux during the early stages of the game. While to the best of our knowledge the players never used the phrase, they were clearly "grinding" the Monty quest for its rewards.

Despite the commonality between *Faunasphere*'s goals and most MMOG's quests, *Faunasphere* was designed to be playable largely in a solo manner; players did not need to work together to advance, as is common in games such as *Final Fantasy XI*[10] or *EverQuest*.[11] Some activities, such as zapping pollution, could be done cooperatively to make them easier, and the patronage system did ask players to visit one another's spheres in order to buy various items. But there was no penalty or detriment for going about most activities on one's own, interacting as little as possible with other players. So even as one could play alongside others, the game was different from most other MMOGs in that it omitted grouping mechanics and did not formally support social structures such as guilds.

Faunasphere also borrowed from MMOG design conventions: a marketplace where players could buy and sell items using in-game currency. Unlike most other MMOGs of the time, however, *Faunasphere* was a "freemium" game in that it had a second currency that could only be acquired by spending money. This meant there were two separate marketplaces, one for each currency. This combination is emblematic of *Faunasphere*'s overall blending of design conventions.

Yet in addition to being an MMOG, and sharing some design mechanics from that genre, *Faunasphere* was clearly designed as a product for Big Fish Games's existing customer base of casual game players. Annakaisa Kultima has identified four casual game design "values" that characterize successful products in the casual market. She argues that casual games—in contrast to "hardcore" (or more recently, just "core") games associated with the young male demographic—offer players more acceptable game content (less violence, fewer dark themes), greater accessibility (easier gameplay), simplicity (relatively small number of rules or actions), and flexibility (greater error forgiveness, ability for player to start and stop playing easily).[12] Similarly, Jesper Juul found that casual games tend to have a positive fiction, presuppose little or no prior knowledge of videogame conventions, allow the player to play in brief bursts, and have lenient punishments and excessive positive reinforcement.[13]

Faunasphere certainly featured acceptable game content and a positive setting: As described before, players spent most of their time caring for a group of small, cute animals. Violence was almost nonexistent in the game: The closest thing to violence was zapping pollution and Monty, which was hardly violent in the traditional sense. While pollution could fight back, it did not hurt fauna but rather made them tired and sad. Defeating Monty was required to move further in the game, but otherwise pollution could largely be ignored, as it was immobile and could not chase players.

Perhaps the least "casual" aspect of *Faunasphere* (in Kultima and Juul's terms) was accessibility. Soon after starting a new game, players would find themselves inundated with a variety of items. While the game had many tutorials explaining the basic gameplay, little information was provided as to the use and value of most items. To deal with this, the players collaborated on a wiki and in the forums, making extensive lists of items and their properties. There were many player-created tutorials on the official *Faunasphere* forums, and the regulars seemed generally aware of how confusing the game could be at first, so helping newcomers was considered part of regular gameplay, similar to what Paul found with respect to *EVE Online* players' creation of a space academy for instructing new players in the finer points of gameplay.[14]

Even this brief overview of the game shows how *Faunasphere* carefully combined elements of both MMOG and casual game design, mixing and matching to try to appeal to a new market. The game's design suggests several things: First, it is possible to create an online persistent world that moves beyond the fantasy/sci-fi tropes that currently dominate the market. Likewise, there are ways to encourage players to interact with one another socially without requiring them to do so. Further, game complexity can be integrated in a variety of ways. It also points to how MMOGs and casual games are not necessarily distinct game design genres, nor are their players. Given the right fiction and gameplay, individuals who have never tried an MMOG may give one a chance and become persistent players, just as those who play casual games may be quite dedicated—even hardcore—in their approach to play.

Studying a World: Our Project's History

Our research project was initially conceptualized when *Faunasphere* was still in closed beta in June 2009, becoming official and then continuing through the game's public launch in August of that year, followed by integration with Facebook in early 2010. Our original intent was to understand

how a player community for an online persistent game with a very different fiction and a player base of largely "casual" players understood and played the game. By late 2010, we were starting to wind down our official study of the world, but in early 2011, Big Fish announced *Faunasphere*'s impending closure. With that event in mind, we redoubled our efforts to play and observe the game, documenting that event in March 2011 and subsequently following up with some of its players after the sunset.

It would be easy to say upon reflection that we entered *Faunasphere* hoping to witness the evolution of an online game, but things were never that neat or systematic. As with most in-depth qualitative research, we didn't know what exactly we were looking for until we were part of it, exploring how players understood the game at particular points in time as well as how they reacted to its dynamic, in-flux nature. Certainly we never foresaw the closure of the game so soon after its launch, nor did we expect the levels of discomfort and dislike that some early *Faunasphere* players evinced toward Facebook and the players coming from that platform. But in response to such dynamics, our research foci evolved to ask new, additional questions and to see how such changes made gameplay even more dynamic than we originally imagined.

As a consequence, we were able to chart player engagement and reactions to the larger player community in tandem with the game's Facebook launch, which also helped us articulate the role of beta players in the creation of the game's community. The Facebook launch brought with it not only an influx of new players but dissent within the original community about those players and what "appropriate" play styles should be, in addition to fears and concerns about Facebook itself. And finally, the study turned into an investigation of what happens when an MMOG closes, including documentation of the final days, how players responded, and the aftermath. Because of the brief life of *Faunasphere*, we had a unique opportunity to examine the entire lifespan of an MMOG and see in a holistic way how multiple elements, such as a game's platform, where it exists in its lifespan, its fictional world, and the types of players that are recruited, had (and continue to have) important implications for understanding play and theorizing player activities, beliefs, and interests.

We also believe that *Faunasphere* was a unique game in its combination of gameplay and audience. Many of its players had never tried such a game before, and the player base was predominantly women over thirty-five, in contrast to the typical young male demographic stereotypically expected for videogames. In this environment, women were not a minority group—they were the norm. And although some of them were

experienced MMOG or virtual world players, many more were coming to a persistent online game for the first time. In either case, the game's fiction was so far removed from most other fantasy-themed online games that players were undoubtedly forced to work together to optimize their gameplay, or simply to have an enjoyable experience. Those experiences and how players enacted them in such a different type of space are key to articulate, as they challenge our expectations for player "types" and play "styles"—*Faunasphere* players, of necessity, could not rely on past game tropes to advance.

A Researcher's Toolkit: Different Methods and Approaches

This study used a mixed-methods approach that extended over a period of more than two years to document the beta period (which we experienced only the very tail end of), the public launch of the game, its Facebook integration, and its ultimate closure. In each chapter, we provide relevant details about where selected data or information originates from, but it's helpful to give an overall picture of how this research project evolved. To start, and as we mentioned previously, we began this study as the game was being publicly released, and the future of *Faunasphere* seemed bright. We began playing the game informally to acquaint ourselves with gameplay, and we also began reading the forums regularly. We took notes and wrote questions to ourselves based on those actions, and then we consulted with the developers, asking them for basic player usage data. We also interviewed one of the game's community managers to gain more perspective on the players. With this basic material, we developed a qualitative and quantitative survey that would reach a large population of the game's players. The survey gathered more than 670 responses and was hosted and promoted by Big Fish Games, with whom we shared that data. We also continued to more regularly monitor the forums and play with the game, although we were not engaging in regular or deep enough gameplay, nor interacting with the player community extensively enough, as to constitute a digital ethnography of the space.

Upon gathering our initial data, we began to write what has become the first chapter of this book, exploring who players of the game were and why they played. Shortly following the writing of that (then) article, Big Fish announced that the game was slated for closure on March 15, 2011. Responding to that event, we continued to monitor the forums and game and then posted requests for in-depth interviews via more nuanced qualitative questionnaires distributed immediately after *Faunasphere*'s closure.

More than two-dozen individuals responded to our call, and we gathered detailed information about how players responded to the closure, their relationships with other players in the game, and their relationships with their in-game avatars—their fauna. We also were in the game world during the game's final day, and we witnessed the sunset event firsthand, taking notes and screenshots and informally talking with players in the game's public spaces. Following that, we continued to monitor the Facebook group that players created shortly before the game's closure, and we have also (informally) played several of the games that *Faunasphere* players have moved into, including *Glitch* (also now closed).

Throughout this book, we use pseudonyms when referring to our participants. While gathering our data, we noticed that many used their Facebook name in communications with us (we contacted the majority through their Facebook group) and that many of these names were obviously fabrications. A significant number used a name such as "Quebecker Faunasphere," which may seem odd to those who did not play the game. When *Faunasphere* launched, it was browser based, but then it moved to Facebook as well. As we discuss in chapter 3, although players were not required to access the game via Facebook, special gifts were made available to Facebook players. This led to some upset in the original *Faunasphere* community, as some members did not trust Facebook's privacy controls and did not want to use the site. However, the promise of additional loot eventually lured some to try accessing the game that way, and to do so they created "alt" or "fake" Facebook accounts, strictly for the purpose of playing the game. Because many players communicated with us via these "fake" Facebook accounts, and we did not ask for gender on the questionnaire, we cannot speak to the gender breakdown of this portion of our data, but we have no reason to believe it differs from our findings in the first survey, as discussed in chapter 1.

What's Inside This Book: Previewing the Contents

When we started to organize material for this book, a few chapters seemed logical in their focus: one that explored what types of players we found in *Faunasphere*, a chapter about the game's ending, and a chapter about the importance of beta players on the creation of the player community. Yet while writing up that work, we also realized that the platforms on which the game ran (the web and then also Facebook) and the player–fauna bond were equally worthy of sustained discussion. Why were those the most important themes rather than others? This brief overview of the chapters should make our decisions a bit more clear.

Chapter 1 opens with a discussion of the demographic data gathered in our first survey of *Faunasphere*'s players. It explains who was playing *Faunasphere*: information about not only their ages and genders but also what other kinds of games they played and how they came to *Faunasphere*. This chapter also explores the question of why *Faunasphere* players played the game at all. By asking those questions, we arrived at one of this book's major contributions: problematizing accepted models of player behavior and motivation. In "Introducing the Caretakers," we show how traditional models' concepts such as "achievement" and "socializing" were crafted in the context of games all falling in the "fantasy" genre and how concepts such as "achievement" were very different in *Faunasphere*. For instance, a major achievement in a typical fantasy-themed MMOG might be slaying a dragon, whereas in *Faunasphere* major achievements revolved around hatching eggs and breeding new fauna.

Chapter 2 turns to examining the game's beta players and their role throughout the life of the game. We talk about the importance of a beta period and beta players in shaping this (or any) game's future culture. The chapter details who the beta players were in *Faunasphere* and how they went about playing the game. We found that betas created a fairly unique approach to playing *Faunasphere* in comparison with other online games, building a "culture of niceness" that both helped and hurt the player community. We spend time deeply analyzing this culture and its expression via forums, survey responses, and interviews with players. We also discuss how beta players were viewed by later players of *Faunasphere* and how players came to differentiate themselves from one another. In this instance, such distinction was quite different from other concepts of gamers such as "power gamers" and "casual gamers" that other scholars have explored.

Just as when a player joins a game has implications for his or her role in its community, the platform on which that game runs, it turns out, is equally important. Chapter 3, "Shifting Platforms and Troubled Ground," questions the role of the software platform on which a game runs and explores how platforms have implications beyond their technological specifications. *Faunasphere* was originally launched as a stand-alone browser-based game, but it was later integrated with the Facebook platform. This augmentation resulted in so much more than an influx of players—the differing expectations for game players from a Big Fish Games background versus those coming from a Facebook background caused a clash of behaviors and interactions within the game and its forums. Likewise, the use of the Facebook platform's standard game-design technique of "free goodies" caused distress among traditional players, some of who adamantly did not want to migrate to Facebook yet still wanted to be

treated equally with respect to game incentives and rewards. This chapter discusses the clash of sociotechnical factors that occurred when *Faunasphere* became accessible via Facebook.

Chapter 4, "The End of the World," moves from the game's beginning to its end, exploring how players experienced *Faunasphere* during its final days and its ultimate closure. Here we make the point that the closing was not just a specific moment but rather a sequence of distinct stages, with each stage characterized by both a significant event and a change in player behavior. The first stage started with the closure announcement: an e-mail to all *Faunasphere* players and simultaneous forum posting announcing that the game was to close in a month. Players responded strongly, voicing emotional reactions on the forums. Preclosure activities followed and were characterized by players changing their goals and play styles in anticipation of the game's closure. Next was the game's sunset: a term referring to the game's actual shutdown and what players were doing at the moment the proverbial plug was pulled. Finally, we witnessed a decline in activity, where players figured out ways to stay in touch without *Faunasphere* and keep some semblance of their online community alive. We end the chapter by discussing the implications of what we observed for researchers of other MMOGs. In particular, we argue that studies of virtual worlds and their players must take into account the current state of that world, as for example we found that players previously uninterested in some aspects of gameplay, like achieving goals, suddenly became very interested in them once the closure was announced.

Chapter 5, "'Why Am I So Heartbroken?': Exploring the Bonds between Players and Fauna," tackles the subject of game avatars and their role in enabling player activity as well as their potential for meaning making within games and game communities. A unique aspect of *Faunasphere* was how players related to and controlled their fauna, which were only loosely analogous to the characters and avatars found in other online games. Players didn't have one central avatar to control (or even a "main" and series of "alts") that was supposed to represent the player; instead, players were addressed as "caretakers" by the game and put in charge of raising and caring for multiple animal-like fauna. This stands in sharp contrast to most MMOGs, where players spend much of their time with a single character that is meant to represent the player as an individual within the game's space or fiction. *Faunasphere* players viewed their fauna as pets they were caring for, not as representations of themselves. As such, many theories of the nature of player–avatar relationships are strongly challenged by *Faunasphere*. This section examines these theories and argues that they are at best genre-specific.

The conclusion closes the book with a recap of the major theoretical implications for scholars of games and MMOGs, focusing on the themes of the lifecycle of a game, the role of fiction in contextualizing activities, player–avatar relationships, and the implications of platforms. We also spend more time discussing the role of gender in gameplay and what it meant (and didn't mean) that the large majority of *Faunasphere* players were female.

We have also included an appendix, which offers an extensive description of *Faunasphere*: what it was, what players did in the game, and the world's driving fiction. It is heavy on description and includes a variety of images illustrating how the game worked. This should be considered a supplement to descriptions within individual chapters, which have included relevant details as needed. However, because *Faunasphere* is no longer playable, we wanted to provide as complete an understanding of the game as possible to interested readers and so have created the appendix as a compendium of how the game worked as well as its core gameplay and fictional elements.

Our Key Contributions

While studying a casual MMOG that drew predominantly adult female players contributes to the game studies literature about players and new genres of games, we believe this book makes additional important interventions in the field. Specifically, and as individual chapters will explore in depth, there are five key contributions that this study makes to the literature of game studies, particularly in the areas of player studies as well as virtual world, social, and casual games theorization more generally.

First, the book offers an analysis of a persistent, casual/social MMOG experience from its beta to its sunset period. At the time of this writing, no other game studies book tracks the lifecycle of a particular persistent online game to see how the game evolved in terms of game design as well as how the player community responded to changes and various events. This was made possible due to the brief life of *Faunasphere*, which by the standards the commercial game industry marks a failure but for researchers creates a valuable opportunity. In our case, we were able to see how a game goes from the optimism of beta periods and public launches, through the inevitable growing pains of an increased player base, and then through to a game's ending and its subsequent fallout. Because we were able to witness such events in a compressed time period, we could in turn see how players shifted play styles and interests, how they reacted to other players, and how the introduction of new platforms for play influenced the player base and their perceptions of both Big Fish as well as Facebook. Beyond the individual play periods, it suggests that the

creation of models of "player types" or "player typologies" falsely isolates player practices—freezing moments in time—that are much more dynamic in practice than we have previously considered. These themes are particularly prevalent in chapters 2, 3, and 4, which examine the beta period, the effects of the Facebook launch, and the closure, respectively.

Second, the book retheorizes player–avatar relationships, arguing that much current theory relies on a model of one player–one humanoid avatar, which does not account for the increasing complexities that games now offer to players. While some scholars have argued for multiple ways of seeing avatars—as tools or masks[15]—the dominant approach has been to understand them as comprising a hybrid or projective identity with the player, coconstituted through the act of play. Yet most such models rely on singular avatars that players must "advance" throughout a game. We argue that a growing number of games offer no such easy relation or avatar choice, but we must still understand how players think about and conceptualize the avatars with which they interact. Just as *Faunasphere* encouraged players to envision their fauna as pets to care for, other games may push players to see avatars as resources to gather or develop, or perhaps as models on which to build. We argue that there is no one-size-fits-all approach to understanding the player–avatar(s) relationship, and we explore an alternate model for understanding such activity via players and their virtual pets. These topics are explored in depth in chapter 5, although the fact that players were playing with their fauna, not as their fauna, informs much of our discussion throughout the book.

Third, because of its comprehensive coverage of the lifespan of *Faunasphere*, the book argues for consideration of the temporality inherent in persistent virtual worlds and how that affects players and the overall player community. This is covered through an analysis of (1) beta players and how they set the tone for the resulting game community (chapter 2) and (2) how the game's closure resulted in changes to many players' play styles and play frequencies (chapter 4).

Our study of beta players is unique in game studies, providing an important contribution to understanding how player communities are shaped in online games. Who is chosen to play in the beta plays an important role in shaping the community, and the world's fiction likewise helps set the tone for pushing player interactions in one direction or another. Additionally, we argue that beta players not only test a game for developers but also through their labor and play come to define themselves as experts and as the pioneering players in the game subsequent to its final release. Their work to establish norms for play—in the case of *Faunasphere,* a

culture of helpfulness—shaped expectations for later players, who then chose to either accept the norms and be part of the community or oppose the norms and define themselves as outsiders. By examining how betas see and enact their roles both during and after the beta period, as well as how developers respond to beta, we offer greater understandings of how communities for online games take shape, in positive as well as negative ways. We also raise questions about the temporal nature of online games—given the short duration of *Faunasphere*, beta players likely had a stronger influence on the game's community, whereas with a longer-lived MMOG, it is likely that the norms of beta players have less force over time.

Another key aspect to understanding the temporal nature of online games is the lifespan of the game itself and how a closure affects player practices. Because we were able to study the final days of *Faunasphere*, we were able to witness (and question players about) how players may have changed their play styles and play frequencies in response to the announcement. Our findings—that some players dramatically increased their play while others quit upon hearing the news; that players chose new goals and directions for their play that had previously not interested them—force us to ask how game studies scholars should study the nature of play in such spaces. Clearly the coming closure affected players' attitudes and play styles in dramatic ways. We posit that similar (but more subtle) changes in player behavior may occur in other games at different points—such as when servers are merged or players suspect a merger, when players hear that subscriptions are down, or when players have changes in their own lives that may prompt new styles of play to take shape. Thus we argue that the temporal span of an online game is a key element to consider, just as the lifespan of a player is similarly important to keep in mind.

Fourth, we argue that the platform a game runs on has significant impacts not only on the game as a technical achievement but also on how players choose to interact with(in) the game (or not). We demonstrate this to be the case in chapter 3 through an analysis of *Faunasphere*'s move from web-only to Facebook integration and the impact this had on the player community as well as on perceived expectations of players. Following Montfort and Bogost,[16] yet further complicating their thesis, we argue that a game's software platform may be just as important as its hardware platform in contextualizing player activity and reception.

Fifth and finally, we believe this book makes an important contribution due to the player community being studied: Older adult women have traditionally been associated with playing casual games and social games,

but they also in this case became avid players of a persistent, game-based virtual world. Their activities and interests in this space demand a reconsideration of women players, their interests, and how we understand their approach to games more broadly.

While our study found that many of these players were new to the world of online games and MMOGs, they were experienced casual game players, many of whom had strong networks or ties to other players in the Big Fish Games community. They were keenly interested in trying a new game and approached the experience as they did their other gameplay experiences—through cooperation and help with other players. They also challenged stereotypes of casual players by playing for long periods, daily, or even for multiple play sessions a day. They spent a considerable amount of money on what was nominally a "free to play" game, and they had little desire to quit playing. Further, although being social was a key draw for some, achievement and exploration in the game were the central drawing points for others, as was the ability to be creative. Through their actions, these players challenged most of our previous research about women and games—demanding that we retheorize how we approach gameplay for women (as well as men) and how contexts of play can radically shift what we think we know players will be doing.

With this in mind, we have avoided making claims about "what women want" in games or what makes a game appealing to women. While *Faunasphere* could be considered a gendered play space, with its emphasis on raising and caring for animals in a nonviolent environment, we do not claim a causal relationship between this aspect of the game and its audience. To argue otherwise would be to reduce the (mostly) female player base to their gender. As Jensen and de Castell have pointed out, what "women" (if it is even possible to homogenize such a diverse population) play is always negotiable and context dependent.[17] We believe that to assume otherwise is no different from assuming that women are more likely to purchase a product if it is pink. This book shows that the players who enjoyed *Faunasphere* did so for a variety of reasons and that those reasons changed as the play context changed; none of these reasons are reducible to gender.

Introducing the Caretakers

In studying first text-based multiuser dungeons (MUDs) and more recently fully three-dimensional massively multiplayer online games (MMOGs), the latter a descendent of the former,[1] online games researchers have largely focused on worlds that employ a fantasy-themed fiction. Here and throughout this book, we mean "fiction" in Juul's sense of the term: as the aspects of a videogame, especially its setting and characters, that "cue players into imagining worlds."[2] MMOGs such as *EverQuest*[3] and *World of Warcraft*[4] often feature magic and swords, with Tolkienesque races such as elves, dwarves, and humans. Players typically choose a character, race, and class (such as a warrior, wizard, thief, etc.) and then begin the long process of advancing or leveling up their character via experience points, going from slaying bats and rabbits to dragons and other large and powerful mythical beasts. Players must usually group together to advance, at least at the most difficult levels, and there is usually some sort of story-line for players to follow, even if it does not impact gameplay very much.

Responding to those virtual worlds, game scholars have developed models and theories for understanding the complexities of player behavior in such spaces. Bartle detailed his original four player types—killer, socializer, achiever, and explorer—based on his study of MUDs,[5] which were then further elaborated on by other scholars. Most notably, Yee has attempted to detail styles of play that are more complex, arguing that there are three main components of play in an MMOG—achievement, social, and immersion.[6]

Yet because the fiction of most MMOGs is relatively similar, we have been blinded as to how we are conceptualizing and then interpreting player activity. We have made what now seem to be unquestioned links between styles of play—such as favoring advancement in play—and use or exploitation of specific mechanics—such as grinding to level up. What would happen if a different type of MMOG appeared with different

mechanics, or even with similar mechanics but that had a very different fiction attached? In this chapter, we argue that *Faunasphere* was such a game and that player activity within the game challenges our understandings of what we mean when we refer to play styles such as "achievement oriented" or even "social." This is due to the game's reward structure, which was designed to continually reinforce the player's position in the fictional world. In the context of *Faunasphere*, activities that might be seen as achievement driven elsewhere take on a different meaning.

Using *Faunasphere* and its player base as an example, this chapter argues that just as gameplay is contextual, games researchers must be continually aware of how fiction changes how players interpret mechanics and rewards. Furthermore, researchers must also take into account how play styles that seem similar on the surface can have vastly different underlying motivations and how fiction influences those motivations.

Our First *Faunasphere* Study: Achievements, Motivations, and Rewards

As our study of *Faunasphere* has been a multiyear project, it has naturally involved different methods and avenues of inquiry at different times. The first major component of our study was undertaken in March of 2010, a year prior to the game's unforeseen closure, after we had spent several months playing the game and reading the forums. At this point, we decided to formally learn more about the players of *Faunasphere* and what they found compelling about the game than mere observation would allow. We approached this first part of our study with the following research questions in mind: Who was playing *Faunasphere*? How do players of *Faunasphere* compare with what we know about players of casual games? What role did *Faunasphere*'s fiction play in shaping player motivation? How is achievement expressed in *Faunasphere*?

Because *Faunasphere* blended design elements from MMOGs, casual games, and social games, and (as we found in our survey) was predominantly played by women over thirty-five, answering these questions has required bringing together several areas of game studies research. Specifically, we see the helpfulness of combining theorization done in three areas: gender and games, the emerging focus on casual games and casual players, and the relatively more established work done in MMOG studies. According to the work of Consalvo[7] and Juul,[8] there are increasing convergences in these areas concerning players' play styles (as well as game design) that must be explored. Such work gives us a better understanding of individuals' relationships with games and play and advances theorizing in game studies. Likewise, Jensen and de Castell argue that much work

on women and games has taken the "lack" of women playing games as a central focus or has investigated the stated gaming preferences of women and girls, without understanding the contexts behind those choices. They instead assert that "while girls and women do play, what and how they play is always negotiable, context dependent, and usually not necessarily in the company of other girls or female players."[9] We take those cautions into account throughout this book, as *Faunasphere* featured a prevalence of female game players engaging in activities that contradict as well as sometimes support traditional assumptions about female gamers.

MMOG Studies: Player Motivation and Gender

A central focus for researchers studying the activities of MMOG players has been examining motivations for play, specifically exploring the different reasons for playing and the varying pleasures that players engage in while playing games like *World of Warcraft* and *Lord of the Rings Online*. While Bartle[10] provided one of the earliest taxonomies of player styles, Yee has further fleshed out those models to account for the more complex interests players might bring to their play styles as well as the evolving nature of virtual worlds. Importantly, he suggests that different motivations may not mutually exclude one another and that "MMORPGs may appeal to many players because they are able to cater to many different kinds of play styles."[11] Yee details three main components of playing: achievement (advancement, mechanics, competition); social (socializing, relationship, teamwork); and immersion (discovery, role-playing, customization, escapism), with various players differing on the weights they attach to those various components.

Some scholars have found particular gender patterns in relation to those different styles, with female players scoring higher on social motivators and male players emphasizing achievement.[12] However, Yee has argued that "variation in the achievement subcomponent is in fact better explained by age than gender" and that "male players socialize just as much as female players, but are looking for very different things in those relationships."[13]

In contrast, a recent study of *EverQuest 2* players found that "women are more likely to play for social interaction and the men to achieve," even as "it was the female players who were the most intense and dedicated 'hardcore' players, playing more often (if in smaller overall numbers) and with more dedication than the males (as indicated by lower likelihood of quitting)."[14] But even if women do start playing MMOGs for social reasons, they may also develop interests in competitive or cooperative activities.[15]

Such theorization aligns with earlier work done by Taylor,[16] who studied players of the first *EverQuest* game, finding that many female players enjoyed the challenges presented by the game and took pleasure in advancing their characters, gaining power, and defeating both human and nonhuman enemies in the world. Thus the evidence from MMOG studies suggests that players can have multiple motivations for play, and there is mixed evidence regarding how male and female players align in regard to those patterns.

Casual Games

In contrast to the relatively lower number of female players in MMOGs, casual games have consistently featured a strong female demographic for a player base, with that group also older than the typical male console gamer. In one of the few surveys of players of casual games, Juul drew from the readership base at Gamezebo.com (a portal for news, reviews, and community interactions focused on casual games), finding that 93 percent of respondents were female and the average age was forty-one. Those players were also quite dedicated: 35 percent reported playing several times a day for at least one hour at a time, and 14 percent played several times a day for more than three hours.[17] Confirming that level of play intensity, Consalvo studied fans of the single-player casual game *Mystery Case Files: Return to Ravenhearst*, finding that "many players of casual games are not at all casual in how they play or think about such games. At least some players are heavily invested in anticipating new titles, discussing various aspects of past and future games, and solving the mysteries that some games provide."[18]

Thus adult female game players can be very dedicated to their play, whether it encompasses a "hardcore" MMOG or user-friendly single-player games like those in the *Diner Dash* series. This suggests that players of casual as well as more mainstream games may be anything but casual in how they approach play. Thus we need to be extremely cautious in thinking through their motivations for play, as well as what types of games might "logically" appeal to female players.

Another key point to highlight from recent work on casual games concerns unpacking the term *casual* itself, for as Kuittinen et al. argue, it can refer to "types of games, types of game players, play styles, [and] distribution and production (genre) models."[19] All researchers who have studied players of casual games, further, have concluded along with Juul that "what we *do* know is that the most dedicated players of downloadable casual games are, indeed, extremely dedicated."[20] We must keep in mind that the players of a more seemingly hardcore MMOG and those

playing single-player downloadable games may not be so different in their time spent playing, investment in play, or even play styles.

Starting the Study: Investigating Players

This first portion of our study of *Faunasphere* ran from late 2009 through the closing of our survey at the end of March 2010. During this period, we used a mixed-methods approach to answer our research questions. We began by playing *Faunasphere* extensively yet informally, to familiarize ourselves with the context of the space, as well as to gain familiarity with the lingo and conventions of the game. We also began to read the official *Faunasphere* forums on the Big Fish Games site to gain a better understanding of what (at least some) players valued, how they interacted with one another as well as with the forum staff, and what issues seemed to be of most concern to players. Our presence as researchers during this phase was unknown to the player community; we refrained from posting to the forums and engaging with other players.

During this period, we also requested and received aggregate gameplay usage data from Big Fish Games, and we interviewed one of *Faunasphere*'s community managers to get a better sense of the community surrounding *Faunasphere*. By examining this quantitative and qualitative data, we moved to a more systematic method to broadly capture a snapshot of *Faunasphere* players and their gameplay practices.

We next developed a pilot survey, inclusive of both closed and open-ended questions, asking players about their gameplay experiences in the game, their past gaming experience, their feelings about other players, their use of the forums, as well as basic demographics and current play patterns. We pilot tested the survey, and based on those results, we refined its language and rephrased unclear questions.

The survey was designed to be anonymous, although we do have basic location information from respondents including country, state, and city of origin. We also limited participants to those eighteen or older, although Big Fish Games did allow younger players to play the game, with parental consent. When the survey was ready, we contacted Big Fish Games, and they volunteered to have the community manager post an explanation and link to the survey to the game forums and to include a link to the survey in their regular newsletter to players of *Faunasphere*. We kept the survey active for approximately three weeks in March 2010, during which time we received 671 completed surveys.

For this analysis, we have mostly examined frequencies of responses and correlations of various identity and use patterns. We compare this

data with usage statistics provided by Big Fish Games as well as with usage statistics other researchers have found from players of casual and MMOG-style games. We also draw from open-ended responses as appropriate. To analyze those elements, we relied on textual analysis and identified pre-dominant themes arising from players themselves. We cross-checked our analyses and emergent patterns with one another to ascertain whether our findings were reliable and best represented the words of participants.

Who Was Playing *Faunasphere*, How Much, and Why

Before exploring motivations for play, it's useful to give some details regarding what types of individuals were playing *Faunasphere* at the time of the survey and some basic information regarding their play frequency and duration. Overall, our survey results showed that the players of *Faunasphere* mirrored the demographics of typical players of casual games rather than MMOG players, in terms of both gender and age as well as prior game experience, but they also shared the heavy play styles of dedi-cated MMOG and casual game players.

Demographics

Demographically, the survey respondents aligned with Juul's survey of Gamezebo.com readers.[21] Of the 671 respondents, 93 percent were female, while 71 percent were over the age of 35. In terms of prior game experi-ence, the majority of respondents were new to MMOGs: 61 percent of respondents had never played another MMOG, while another 5 percent did not know what the term *MMOG* meant; only 10 percent of respon-dents reported currently playing another MMOG. However, younger players were slightly more likely to play another MMOG than older players. While 18 percent of 18–24 year olds reported currently playing another MMOG, fewer than 10 percent of 45–64 year olds did the same.

The data also showed that many players were already familiar with casual games before they encountered *Faunasphere*. Overall, 81 percent of all respondents reported being a Big Fish Games customer prior to playing *Faunasphere*, while another 4 percent became Big Fish Games custom-ers due to their *Faunasphere* experience. Despite *Faunasphere*'s mixing of casual games and MMOGs, it clearly attracted more players of the for-mer than the latter. This likely has something to do with how and where the game was advertised; 78 percent of respondents learned about *Fauna-sphere* from Big Fish Games directly, be it via advertising on the Big Fish Games (BFG) website, acting as a beta tester, reading about the game in

the BFG newsletter and forums, or through promotional e-mail. From this data, it is clear that the survey respondents were already active in and familiar with casual games prior to encountering *Faunasphere* rather than coming from a background featuring more traditional MMOGs.

Player Dedication

The data showed that *Faunasphere* players were extremely invested in the game. This is in line with both studies of casual game players, such as Juul's survey of Gamezebo.com readers[22] and Consalvo's study of *Ravenhearst* fans,[23] and studies of MMOG players by Yee,[24] Taylor,[25] and Williams et al.[26] Play sessions among respondents were typically quite long, with 51 percent reporting an average session length of greater than two hours. Another 27 percent reported playing between one and two hours per session; a further 11 percent played between 41 and 60 minutes at a time, on average. The respondents also played frequently, with 41 percent of respondents reporting playing several times each day, while another 37 percent played daily.

Those who played the longest sessions also tended to play the most frequently. Almost 65 percent of those who reported playing several times a day also claimed their average play sessions were more than two hours in length, suggesting the most avid players were in *Faunasphere* for more than twenty hours per week, at minimum, similar to many MMOG players. Additionally, 52 percent of daily players reported average play sessions of more than 2 hours in length. Older players also tended to play more frequently than younger players. While only 19 percent of 18–24 year olds played either several times a day or daily, 53 percent of 45–54 year olds and 48 percent of 55–64 year olds reported similar play frequencies.

However, according to data provided to us by Big Fish Games, the average session time for all players was only forty-five minutes, indicating two possible alternatives: first, that the survey attracted a disproportionately high number of extremely dedicated players (which was to be expected given the distribution channels), or second, that self-reporting players overestimated the amount of time they spent actually playing the game. We are inclined to lend more weight to the first explanation, particularly as other research has found that many players tend to *underestimate* their time spent playing, with women being even more likely to do so than men.[27] Yet the findings do raise an important caution to all games researchers—that relying on nonrandom samples is likely to result in findings that are skewed toward the interests and activities of the most dedicated players.

As noted previously, this part of our study was conducted approximately eleven months before the closure announcement. As we discuss in chapter 4, the announcement had a profound impact on playing habits, leading some players to play dramatically more, others dramatically less.

Fauna and Membership

Further evidence for the dedication of the survey respondents can be seen in the data regarding fauna ownership and membership levels. In *Faunasphere,* players owned multiple fauna at the same time, with the exact number depending on the status of their membership—free members were limited to three fauna, while platinum members could have up to thirty. While only one fauna could be used at a time (analogous to the multiple characters a player could have in a typical MMOG), it was simple to switch to another whenever the player desired. All fauna began at level one and could reach a maximum level of twenty. When asked about their highest-level fauna, 18 percent of respondents reported that they had at least one fauna at level twenty and that they still used that fauna. Another 33 percent had their highest-level fauna at level sixteen or above, and for another 29 percent of respondents, their highest-level fauna was between eleven and fifteen. Altogether, 80 percent had their highest-level fauna at level eleven or higher.[28] Again this stands in contrast to the data from Big Fish Games, which reported that (excluding level zero fauna) the average level of all fauna was 2.6. The data further support our conclusion that the survey attracted the most dedicated players.

In line with a growing number of social games and MMOGs that feature free accounts with optional premium elements to purchase,[29] players of *Faunasphere* had different types of accounts corresponding with their membership level. This level determined how many fauna the player may have had at once and also determined a monthly payout of "bux." Bux was a premium currency (in addition to the standard "lux") needed to purchase certain items. Details for the various membership levels are summarized in Figure 2.[30]

From this data, we can see that 77 percent of survey respondents were paying for an optional monthly *Faunasphere* subscription. Furthermore, 63 percent of respondents had made one-time purchases of bux. Of that subset, 52 percent reported having done so four or more times, and slightly more than half (57 percent) reported an average purchase amount of 2,400 bux or more. It should be noted, however, that bux were prorated such that when larger quantities were purchased the cost per bux

Membership type	% of respondents	# of respondents	Max fauna	Cost/Mo. (USD)	Bux/Mo.
Platinum	57.10%	382	30	$9.99	4,000
Gold	14.05%	94	15	$4.99	1,500
Silver	5.83%	39	6	$2.49	600
Free	23.02%	154	3	$0.00	0

FIGURE 2. Membership level distribution.

decreased; purchasing bux in amounts of 2,400 or more was the most cost-effective option. Additionally, higher membership levels paid less for bux. As such, a platinum member could purchase 2,400 bux for $4.99 USD, while a nonpaying member would pay $9.99 USD for the same amount. This incentivized players to opt for higher-level, higher-cost memberships. Here again we see that the survey respondents were extremely invested in the game.

It is interesting to note that 64 percent of women players purchased bux, while only 48 percent of male players did so. Nick Yee's earlier surveys of MMOG players found that 22 percent of all respondents reported purchasing virtual currency (however, such purchases are most often illegal in MMOGs) and "male and female players were equally likely to purchase virtual currency," although there was a mild correlation with age (older players being slightly more likely to buy currency than younger players).[31] Our findings are more in line with the practices of those playing social games, where, as Steve Meretzky has reported, women are more likely to buy virtual currency than men.[32] It should be noted, however, that in MMOGs there has traditionally only been one kind of currency, and that currency can be acquired by anyone willing to spend the time earning it. In "freemium" games, such as *Faunasphere* and many "social" games, it is often the case that the premium currency is *only* attainable by spending real-world money. It may also be the case that comfort with or loyalty to Big Fish Games played a part in players' willingness to purchase currency or buy a paid membership. While 83 percent of women were Big Fish Games members *before* playing *Faunasphere*, only 56 percent of men were members before trying the game. Membership with Big Fish Games entails paying a monthly fee, and so prior customers may already have been familiar with that system and trusted the company (for either the quality of its games or its customer service) enough to pay for their

experiences in *Faunasphere*. Thus it remains an open question as to what factor was more important for purchasing paid memberships and virtual currency—whether it was gender or prior experience with Big Fish Games. However, we did find that older players were more likely to buy bux than younger players, with the following distribution for female players (see Figure 3). Men's bux-buying frequency did not change appreciably with their age (although the N was so small, it is difficult to generalize here).

Lastly, the likelihood of being a paying member also rose with age. While 54 percent of 18–24 year olds were free members, only 26 percent were platinum members. In contrast, only 17 percent of 45–54 year olds identified themselves as free members, while 68 percent were platinum members. Getting older still, only 12 percent of 55–64 year olds were free members, but 71 percent reported being platinum members.[33]

The significance of this data and its relation to player dedication derives from the design of the game: Paid memberships allowed members to own more fauna and purchase premium items, although neither of those activities was essential to progress in or necessarily enjoy the game. But the privileges that came with membership (more fauna and more bux) did make the game more rewarding to play for individuals interested in particular gameplay mechanics and elements. Most critically, much of the game revolved around breeding fauna and decorating one's sphere in unique and/or aesthetically pleasing ways. Doing both was made easier through access to a premium account. Such accounts allowed players to embark on more ambitious breeding projects, since more fauna could be stored and thus held in reserve for experimentation to breed for particular fauna characteristics or even types of fauna. Conducting extensive breeding projects while being limited to three fauna was simply not possible.

Age	% that bought bux
18–24	38%
25–34	54%
35–44	63%
45–54	70%
55–64	78%
65–74	69%

FIGURE 3. Female players that bought bux outside of membership.

Similarly, some items could only be purchased with bux, with these being luxury, nonessential items. Such items were largely nonfunctional yet served as decorative items in players' spheres, which were visited by other players and sometimes entered into design contests. Thus to be as creative as possible and obtain what were potentially exclusive items, players had to be willing to either pay for bux via regular purchases or sign up for a paid account, which gave access to regular bux payouts as well as discounts for additional bux purchases. Thus we can see that the survey respondents, although playing what the industry terms a "casual game," were definitely not casual players.

Loyalty

Finally (and tragically), respondents were quite loyal to *Faunasphere*. Overall, 65 percent of players indicated that they would either keep playing the game indefinitely (recall that this survey was active some eleven months prior to the closure announcement) or "play even more" in the future. Only approximately 6 percent reported they had either already stopped playing or had plans to quit "soon." Such findings are also in line with Yee, who has also found that female players are more often invested in games than their male partners, reporting less likelihood of leaving.[34] Our frequencies were too low in regards to male players to make reliable assertions in that regard, but interesting differences do arise between paying and free members; free members are by definition less invested in the game.

When exploring the future plans of free members in relation to platinum members, we found the following: First, platinum members were more likely to state they will be playing either more or at about the same level in the future (68 percent) than were free members (56 percent). Free members were slightly more likely to report planning to play less in the future, because they were either busy or losing interest (27 percent of free players versus 21 percent of platinum players). Finally, 10 percent of free members reported that they either were not currently playing anymore or had plans to quit, while only 5 percent of platinum members reported such feelings.

Motivations for Play

In order to study what players enjoyed the most in *Faunasphere*, we asked them to rank a list of activities comprising the game's central components. Contrary to the results of Williams et al.'s study of *EverQuest 2* players,[35] our results showed that the predominantly female players of *Faunasphere*

were largely motivated by activities that signified achievement, as opposed to the expected social elements other researchers have attributed to female players.[36] Respondents were asked to rank a set of in-game activities on a scale from 1 to 7, where a 1 corresponds to "most favorite" and a 7 "least favorite." Results are shown in Figure 4. The three most popular activities were "Completing Goals," "Leveling Up Fauna," and "Breeding Fauna." Each of these fall under the achievement component in that they related to progressing within the game, though—as we discuss later under "Players, Fiction, and Rewards"—these are all somewhat related.[37]

In contrast, activities that could have been considered social[38] were ranked quite low. Only 10 percent of respondents rated "Interacting with Friends" as their most favorite activity, with the activity's average rating only 4.2. Additionally, only 24 percent of respondents reported having more than one hundred friends on their friend list, despite a maximum of three hundred. Friend lists were also somewhat utilitarian in *Faunasphere*, as they allowed players to visit the spheres of friends, where they could either buy needed items or simply view other players' sphere decorations. While they also let players know if that friend was available, the relatively low number of friends coupled with the functional aspects suggests that this function was not widely used for sociality.

This is not to suggest that there was no social activity in *Faunasphere* but rather that it was not reported as the central aspect of the game for many players, and indeed the game offered few incentives or requirements for socializing or interacting with other players in a structured manner. When asked how often they actually chatted with friends over in-game

Activity	Average ranking
Completing Goals	2.7
Leveling Up Fauna	3.0
Breeding Fauna	3.4
Building/Decorating My Sphere	3.8
Interacting with Friends	4.2
Raffles and Patronage	5.4
Special Events	5.5

FIGURE 4. Average rank of in-game activities. Respondents ordered the set of activities from 1 to 7, with 1 being their favorite and 7 their least favorite.

open chat, 42 percent reported doing so always or frequently, while 58 percent reported doing so occasionally, rarely, or never. When asked the same question about how often they chatted with friends in-game via private message, 40 percent reported doing so frequently or always, while 60 percent reported doing so occasionally, rarely, or never. The majority of respondents (66 percent) did not know any of their in-game friends outside of the game.[39] Participation in the official *Faunasphere* forums was also low, with 61 percent reporting that they posted to the forums rarely or never. This statistic is surprisingly low given that, as we have already seen, the survey seems to have been taken by the more dedicated players. The question whether less-dedicated players had similar motivations for play is an open one.

From this data, it is clear that the most dedicated *Faunasphere* players were women who came from a casual games background, had little MMOG experience, and were predominantly motivated by the achievement component. This aligns with Taylor's research into female players of *EverQuest*,[40] who enjoyed elements of the game such as leveling up and defeating enemies, which would fall under the achievement component. Williams et al.'s study of *EverQuest 2* players found that female players were more motivated by the social component than males, but note that even if these women began playing for social reasons, these reasons are not necessarily why they continue to play.[41]

Players, Fiction, and Rewards

One of our research questions asked what role the fiction of *Faunasphere* played in shaping player motivation. While the data from our survey supported some earlier findings about the importance of achievement in play, the fictional world of *Faunasphere* offered some complications to how we conceptualize our ideas of achievement and what "counts" as such activity. To review, survey respondents overwhelmingly preferred in-game tasks and activities that generally fell under the achievement component. The only social component that was included as an option was "Interacting with Friends," which out of seven choices was ranked fifth, suggesting it was not very popular among respondents. However, unlike in most MMOGs, players of *Faunasphere* had no "avatar" in the traditional sense. Rather, players were addressed directly by the game as "caretakers." Each player had a number of fauna to select from, which was functionally similar to the different characters a player of a traditional MMOG might have. However, these fauna were seen as being *cared*

for by the players (and the game); the player's identity was not projected into the world beyond the mouse pointer being used for interaction (more on this in chapter 5). This attitude was reflected in the forums, where players continually expressed sadness over having to release a fauna when at their limit or when players would post announcing that one of their fauna (not the players themselves) had reached level twenty. Fauna were seen as being distinct entities from the players. This notion of "caretaking" was extended into the game's reward structure. *Faunasphere* featured a cascading reward system with two defining attributes: a mix of predetermined and user-selected rewards and an overall focus on enabling players to fulfill their fictional roles as caretakers.

The primary reward in *Faunasphere* was lux, the basic currency. Lux was earned by zapping pollution or completing goals, and it was used to purchase goods from shops or other players' totems. Whenever lux was earned, an equivalent amount of experience points (XP) was earned at the same time (experience points were not lost when lux was spent). When a fauna earned a predetermined amount of experience points, it gained a level—much as in other MMOGs—and laid an egg. Eggs were used to hatch new fauna and could be bought, sold, gifted, and traded just like other items in the game. At the highest level, *Faunasphere*'s reward structure can be thought of as a series of deterministic relationships. Earning lux always entailed earning XP, which always entailed earning new eggs. This process is illustrated in Figure 5.

In Figure 5, the three main reward elements are indicated by the three ovals. Black arrows between elements indicate a deterministic relationship: Lux always became XP, which always led to eggs; players could not interrupt or stop this progression. Also in this diagram are two secondary elements: caretaking and economic power. "Caretaking" refers to items, events, and actions associated with the player's fictional role as caretaker, while "economic power" refers to lux or the ability to acquire lux.[42] Note that in the diagram there is a direct relationship between earning XP and caretaking. This is because of the players' roles as caretakers, and from forum postings, it was clear that many players saw themselves as such. Leveling up a fauna was not about gaining power or prestige as it is in most MMOGs—fauna did not become better pollution zappers or quest completers—but rather about caring for that fauna. The connection between eggs and caretaking is considered a potential expenditure because the player did have some choice. Eggs could be hatched, thus increasing the player's number of fauna, or they could also be exchanged like any other item. Thus they could be considered to represent economic power as

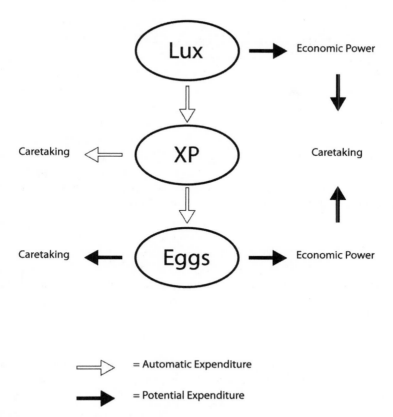

FIGURE 5. *Faunasphere*'s reward structure.

well, as indicated in the diagram. Finally, economic power could always be expended on caretaking. Many of the items available in the game related to fauna, either directly (in the case of food items and eggs) or indirectly (items used to build dens, faunasphere components). As such, what seemed a varied, multilevel reward structure was actually tightly designed to direct a player's attention back onto his or her fauna. Furthermore, the cascading nature meant that whenever a player was rewarded, they were also working toward a long-term reward: earning lux now meant earning eggs later; players were always progressing toward better rewards. That this structure was effective can be seen in the data on player motivation, which show that a vast majority of players favored activities that either

resulted in one of the three main rewards (completing goals, leveling up fauna) or depended on them (breeding fauna).

The significance of this structure and its ties to *Faunasphere*'s fiction is that it complicates previous notions about the nature of achievement. As described before, the survey data showed that the three most popular in-game activities were completing goals, leveling up fauna, and breeding fauna. On the surface, these all seem to fall under Yee's achievement component,[43] but as shown in Figure 5, the rewards for all these activities could be seen as nurturing, as all were beneficial to the player and his or her fauna. Furthermore, we know that the fictional world of *Faunasphere* is significant to the players, as indicated by the previously noted forum postings. Additionally, Juul[44] and Kultima[45] both identify positive fiction as a key trait of casual game design. Given that the majority of respondents were also players of casual games, we can conclude that the game's fiction was at least in some degree a significant factor in their choice of games. *Faunasphere* shows that an analysis of what constitutes "achievement" or progressing within a game must be contextualized within the game's fiction, as similar activities can take on very different meanings for players.

Conclusion

As the market for videogames continues to expand, it is probable that more hybrid spaces such as *Faunasphere* will appear. In order to study and understand these new types of games, and their players, it will be necessary to rethink many of our assumptions. By examining how *Faunasphere* blends elements of casual games and MMOGs, this study has attempted to do just that.

To reiterate, we approached this portion of our study with the following research questions in mind: Who was playing *Faunsphere*? How did *Faunasphere* players compare with what we know about players of casual games? What role did *Faunasphere*'s fiction play in shaping player motivation? And last, how was achievement expressed in *Faunasphere*?

In terms of question one, the data aligned with Juul's study: Both surveys found that players of casual games are predominately women over the age of thirty-five.[46] This was not surprising, given that the majority of survey respondents were playing casual games before coming to *Faunasphere*, and indeed most were already active patrons of Big Fish Games. When we first published these findings in the online journal *Game Studies* in early 2011,[47] we suggested that the fact that these players had moved from typical casual games to an MMOG indicated the potential for movement toward other genres. However, *Faunasphere*'s

subsequent closure and the spread of social and free-to-play games since then complicate that suggestion, and more research is clearly called for. Many of the players themselves continued on to another online game— *Glitch*, which has subsequently closed as well—which suggests players' interests in continuing their explorations of new gameplay possibilities. Others continued or started playing social games on Facebook and discuss their continued sadness about the closure of *Faunasphere* via their group Faunasphere Memories. Yet we need more longitudinal studies of players across game sites to better understand how players' beliefs and attitudes toward videogames evolve over time.

Additionally, our findings align with Consalvo's[48] and Juul's[49] prior studies in showing that players of casual games exhibit a high degree of dedication to their game playing. However, when considering social game players, differences in the findings become important to note. The company's decision to bring the game to Facebook (and presumably reach a wider audience, both in sheer scale as well as demographically) was not a success. At its most popular, *Faunasphere* on Facebook claimed more than 340,000 monthly active users (MAU), but by January 2011, that figure was down to slightly more than 25,000 MAU. Thus although the game featured many elements of similar social games (persistence, positive themes, short gameplay sessions), it did not fare well against competitors such as *FrontierVille*.

For questions two and three, we found the answers to be intertwined. *Faunasphere*'s reward system was closely linked to the game's fiction: All the rewards further enabled the players to enact their roles as caretakers. As such, achievement was also connected to caretaking: Major accomplishments, such as breeding a new fauna or reaching level twenty, can be related back to caretaking. Thus achievement in *Faunasphere* was different from achievement in a traditional MMOG, where major accomplishments are typically connected to gaining power within the game world. Although *Faunasphere* was just one example, it shows that *achievement* on its own is too broad a term and needs to be contextualized within a given game. The fictional world of a game directly impacts the nature of achievement in that game.

Likewise, the design of the game privileged achievement mechanics over social mechanics. *Faunasphere* did not require players to group together to achieve goals, zap pollution, or explore. Instead, those activities remained possible when playing alone. Although players had to interact with others if they wished to trade or buy and sell eggs as well as sphere decorations, those activities could easily be accomplished via the game's marketplace feature and did not require synchronous, coordinated interaction.

Compounding this, there was also no reason for players to form more permanent social groupings such as guilds, as they served little purpose beyond what could be accomplished via the friend list. Thus underlying structures of the game that likewise supported its fiction also worked to diminish interest in complex forms of socialization among players. Such decisions reveal how designed components of a game shape resulting player activities and interests and should again cause us to question what different player groups—such as the female players of *Faunasphere*— "naturally" like or find important in motivating them to play.

In conclusion, our call for contextualization with regards to achievement, rewards, and fiction is similar to Jensen and de Castell's insistence on contextualizing the preferences of women gamers. While *Faunasphere* was predominately played by women, it would be fallacious to assume that we can draw conclusions about women gamers as a homogenous group based on the game's design. We do not argue that women liked *Faunasphere* because of the emphasis on caretaking, for instance. Rather, what this study has shown is that new, hybrid spaces like *Faunasphere* are likely to continue emerging in various forms and that as researchers we must continue to adapt our theoretical toolsets as necessary, paying attention to the complex interplay of design structures, game fictions, and player actions as they work in tandem with one another.

Those Were the Days

Interacting with Beta Players

Just as most massively multiplayer online games (MMOGs) are designed without an end, it can also be difficult to identify when they begin. While all games will announce an official launch day when the game is open to all players, those official dates are often months if not years after the game actually went online. Most contemporary MMOGs now have closed alpha sessions and both open and closed beta periods in order to test run the world. During these periods, the games are not always consistently available, and they are definitely not open to the wider public. Such worlds may blink into existence for a weekend test and then just as quickly shut down for upgrades and maintenance. Players who see and play in the MMOG during these periods may find large and small changes to the world or even the erasure of all their progress. That group of players is carefully selected and managed and generally bound by a nondisclosure agreement (at least in the early stages of a game's development) in order to manage the dissemination of information about the game. And as the game comes closer to public release, increasingly larger numbers of testers are brought into the game to test issues that only a greater population can elicit, such as stress testing of servers and more diverse, large-scale community interactions.

All these factors suggest that the beta period for an MMOG is a vitally important period for game developers and the resulting game, and so in turn for game studies scholars to understand. Yet we know almost nothing about beta periods and beta players in MMOGs apart from a few journalistic accounts and some developer stories. This chapter will move us further along in understanding such a key period in an MMOG's lifespan. Such periods and players are important not only for understanding how a particular game takes shape but also for understanding how certain groups of players, key game design elements, and the interactions

between beta and open players shape the future state of an MMOG and its community. Likewise, the collective memories that are created during the beta period and following the open release of the game are perhaps more important than what actually happened during the "real" beta.

This chapter encompasses a recounting of the history surrounding the development of *Faunasphere*, its beta period, and its subsequent launch, including the relaunch via Facebook. We also explore how beta players remembered the beta period and how they later interacted with the open community of *Faunasphere* players. Finally, we conclude by discussing how elements such as a game's fiction and the role of collective memory all have consequences for how players play and understand games and how we can understand their words and actions.

The Temporality of Data and Player Memory

As with many empirical accounts of virtual worlds, our data were not taken from a singular moment in time—instead, it was gathered during and after the game's lifespan and represents moments from the beta, from the web-only version, from after the Facebook launch, as well as during the game's final day and then following that event. While this gives us a rich account of how players understood the game and its community and does give us a sense of how various elements shifted over time, it also raises important questions about the nature of remembering and the role of memory in reconstructing past events. For example, most of the players we talked with who had participated in the beta test saw it as a largely positive experience, and many of them continued to play after the game was released to the public and up until the game's closure. But the information we gained directly from players about participating in the beta test was by necessity more reflective in nature than their experiences during either the open phase or the game's final days. Thus we had to rely on players' memories of events and situations, which may have been easier or more difficult for various players to recall and likewise may have varied in their accuracy.

Our data were also drawn from various points within the lifespan of the game, letting us see, for example, if the larger player community may have changed their assessments, play styles, or frequencies over that span. Our survey captured a time period when the game had already been released on Facebook, and some players had become vocal critics of the new players that the platform brought to *Faunasphere*. And finally, our interviews with players upon the closure of the game reflect their experiences coming full circle. We cannot know how much of what players told us was accurate

and how much was tinged with nostalgia (or regret) in regards to their experiences in beta (or any other period in the game). We can only help to reconstruct the story that players tell themselves and others about the game and their experiences in it—and so what the beta period was *remembered* as being is perhaps equally if not more important than what the "truth" of the situation could have been. We'll return to this assertion in more detail as the chapter progresses, but this is an important point to consider when thinking through how individuals and groups construct accounts—and memories—of past events and actions and what their versions say about the larger community and the need to remember history in a particular way.

Hatching *Faunasphere*: Origins of an MMOG

In spring 2009, Big Fish Games began beta testing for its first massively multiplayer game, *Faunasphere*, billed as a casual MMOG. The move represented something new for Big Fish, which had made its name largely as a developer and publisher of casual single-player downloadable games. Big Fish had attempted other types of game ventures, but prior to this point, it had not invested heavily in social or persistent online games. In 2007, Big Fish and CEO Paul Thelen had purchased the small company Thinglefin, which had formed earlier that year.[1] The company was led in part by Toby Ragaini, former lead designer of more traditional MMOGs *The Matrix Online* and *Asheron's Call*. Thinglefin had already begun development of *Faunasphere*, which Big Fish likely felt would complement and augment its portfolio of casual games.

Development continued and the game went into closed beta in mid-March. Private invitations to try the game were sent out on March 17, 2009, and the game started to be teased on various game blogs, with beta invitations being offered to a lucky few in order to build interest.[2] Over the spring, the game took shape, and increasing numbers of players were recruited to play. No serious setbacks were reported in the game's development, and the game was officially launched as a free-to-play browser-based game on August 14, 2009. At that point, any potential player not yet accepted into the beta test could create an account and start playing, and the game was favorably reviewed on many game sites, such as MMORPG.com, doublegames.com, and mabelgames.com.[3] Almost exactly six months later on February 19, 2010, Big Fish announced that *Faunasphere* would be available as a Facebook application, in addition to remaining accessible via the web. Players accessing the game via Facebook would also have access to special gifts not available via the regular

site. Drawing on Facebook's huge user population (approximately 500 million accounts in 2010), the game succeeded in attracting more players, yet debates were starting to occur in the player community about the Facebook launch and the new players that subsequently joined the game. Despite the move to a platform known for widening the audience for digital games, the numbers of players ultimately did not reach a sufficient level to make the game sustainable for Big Fish. Just over a year later, the company announced the game's closure, and *Faunasphere* shut down on March 15, 2011.

Becoming Ambassadors: Beta Players

Although it's common for MMOG developers to send out beta invitations to influential bloggers and game reviewers, they will also recruit closer to home if they have a stable community of game players who fit their targeted player demographic. So it is not surprising that Big Fish turned to its own community of game players, as they were part of the "casual game" player crowd that *Faunasphere* hoped to interest. The developers sent out a survey and then invitations to a select group of active members but at first kept news of the game relatively quiet. Yet less than a month after beta invitations first went out, the larger community of players at Big Fish learned of the existence of the game and its testing phase.

On March 18, 2009, a poster named christy created a thread titled "Big Fish Games Launching New Virtual World, Faunasphere" in Big Fish's "Chit Chat Corner" forum.[4] Regular Big Fish players then began to discuss the upcoming game and expressed great desire to gain access to it and impatience with waiting for open access to the game. One player, a regular poster named redfish, claimed that Big Fish had circulated a survey about the game approximately a month earlier, but she knew little of the game's current status. A few hours after the thread began, Big Fish executive Paul Thelen wrote and explained to the players the reason they had not yet been invited: "It is a private beta (i.e. we are still testing and refining) so the invite has to be small at first so the world does not explode or go dark . . . what would happen to all the cute Fauna." Players responded with thanks for the clarification and continued to debate what the game would be like, anticipating the opportunity to play with other Big Fish players in a communal space. For example, Savannahcats speculated, "From what I gather you have horse, dog, cat etc avatars and need to nurture and feed them a bit like the Dogz and Catz games (years ago they used to live on your desktop

and if you didn't look after them well enough then they'd die or leave) whilst exploring a virtual world (like Second Life only with less good graphics). It would be SUPER COOL if we could all meet each other at Faunasphere and IM each other."

The thread continued for months following the initial post, as more players were invited and interest in the game grew. The continual presence of the forum thread and its constant updating also served as a reminder to those not yet invited to play of the game's presence and future launch. Lacking more detailed, official information about the game, the thread became even more valuable as a promotional tool for players not yet in the game and a way to discover more about what was going on inside *Faunasphere*.

Those lucky enough to be part of the beta became ambassadors of sorts, explaining to others what *Faunasphere* was like. In one exchange between two beta players that draws from the community's self-identification as "fish" in the "pond" that is the Big Fish forums, Bronzecloud wrote, "It really is a wonderful world [name removed]! The fishies here are so nice and caring . . . after all so many of us are the ones who ended up in FS! I soooo wish that all my friends from here would end up over there too, but some people just don't like that kind of game . . . although it's so hard to think of FS as a 'game' so much as my 'existence' lol!!!" Taamets advised other Big Fish players that the experience was worth a try: "To those veteran fishies, take a word from a newbie in the pond if you will, and when it goes live, try it, or sign up for the beta. you'll never believe you could have so much fun. even my hubby faunaphile (a macho man by his own standards :)) giggles and chats away with all the fauna he meets."

Over time, more invitations to the beta were released, and increasing numbers of players were able to take part in the beta test. Potential players expressed frustration with having to wait for their chance to experience *Faunasphere*, likely exactly what Big Fish was hoping for—the relative scarcity of the testing experience creating higher expectations and excitement surrounding the game and its eventual launch. Like other MMOGs, *Faunasphere* needed to be tested before official release, and the company's loyal customers were a natural place to begin recruitment. They would (and did) serve as evangelists for the product, and they provided detailed feedback as well as (by forum accounts at least) logged extensive gameplay hours for the developers to examine. By slowly scaling up participation, Big Fish was likewise scaling up interest in the game while also shielding the game's potential problems from those with less investment in the game or loyalty to the company.

The Golden Years

Bugs, Lag, Crashes, Wipes, and Lack of Content

Beta testing periods for digital games are undertaken by game developers to see how players respond to game environments, how the technologies of the game (including the servers) withstand the pressures of player activities, how well the game is balanced, and where and how bugs appear in the game. The use of actual players for beta tests (rather than hired testers or QA professionals) is something of a bargain on both sides: players get free access to a game they are interested in playing, and developers receive free labor. It's also key to point out that beta testers are courted not only with advance free access to the game in question but often with the belief that they will be able to offer vital input into the game's design and direction (to a certain degree). Thus it is common to see beta testers take their play work—or "playbour," according to Kucklich—quite seriously, not only enthusiastically playing the game, but happily reporting bugs and glitches as well as reporting on elements of the game they believe are in need of improvement.[5]

Beta testers for *Faunasphere* proved no different, although most beta players appeared far friendlier and more polite than beta testers we have informally witnessed in more traditional MMOGs. For example, in the Big Fish forum threads about the game, Tvfan asks those already playing, "Would any of you fishies be willing to patiently hold my hand and walk me thru this once it's all open so I will be able to know what in the world I am doing?" and the immediate response from pez3 reassures the poster that "I guess we will all hold each other's hands at first."

While a few beta players mentioned lag and crashes in the game, most knew and understood the version they were playing was in constant flux. Technical issues could be approached as problematic or as a challenge to be overcome. As one player explained, "It was an adventure every day, am I going to be able to log on, can I play for more than 20 minutes without the game crashing/locking up." Likewise, although many players were unsure how to play (either because they were new to MMOGs or because of the uniqueness of the game's fiction and gameplay, or both), many took that as a challenge: "In the beginning we were all learning together, every new hatch was a source of wonder." Likewise, another player "had a great time trying to figure out all the doodads, meeting the other testers and adventuring together, just seeing the whole project developing and being a part of it really tickles me."

While some players reported that "the game content got a bit boring at some times," most enjoyed the opportunities the game afforded them to

try out the space. As one player added, "We had fun making up things to do when bored. We would meet in the RG [Rock Garden] and talk or come up with things to do." Players held impromptu parades to show off newly hatched fauna, and some created games of hide-and-seek in the various world zones. Many stated they liked the ability to constantly learn new things about the game and that "it was so much fun learning the game" and "we all worked together to find resolutions, work arounds and we helped each other a lot." Players understood (through regular communication from the game's developers) that more game content would be coming, and many expressed pleasure at improvising activities on their own.

Another key part of their sense of enjoyment came from knowing they played a vital role in testing the game. One player responded to our survey that "I just felt more special and important while playing: the added purpose of beta testing added a whole new dimension to the game that is gone now," while another responded that during beta he or she was "part of a team" and "I was out there to find problems and report them." Such statements convey how players conceptualized the role of beta tester— taking the role seriously and being about more than simply a free ride. Instead, they saw their role as a key element in the game's development and potential success.

In that way, we can see beta testers—even those of a casual MMOG—as valuable actors in the larger ecosystem of game development. Much like the theorycrafters in *World of Warcraft* that Paul discusses,[6] and the modders that Sotamaa has studied,[7] beta testers saw their role as helping to improve a game via their actions—trying out elements of the game, experimenting, and reporting back with their findings. Modders are often recognized as adding value to already-released games, via developer-created tools. They also see their role as increasing the enjoyment of a game for not just themselves but the larger player community. And while some mods may be augmentations of a particular game such as new levels, there are other types of mods that attempt to "fix" what players see as problems with the official release of a game.

Theorycrafters may not be able to change the game they are playing, but they do strive to make the game understandable (and beatable) for a larger player base. And theorycrafters do play a key role in reporting back to developers when they believe game updates potentially "nerf" certain classes or "break" the game in a particular way. Despite their relative newness to the world of MMOGs, the beta testers of *Faunasphere* similarly felt their feedback was a valuable service to Big Fish, helping to identify troublesome areas as well as pointing to issues they felt would

prevent other players from subscribing. Some players, such as Lionheart, were so invested in the game that they worried about the timing of the public launch, as "many [beta testers] felt that the game wasn't ready to go live and were worried that if it wasn't ready it wouldn't be successful. We . . . saw that there were many areas that needed a lot more fixing in order to hold the attention of newly introduced players. Even myself, after having played from May until August, while enjoying the game, I was not ready to pay to play it as I felt there were too many negatives and not enough positives to provide value for the dollar spent."

Of course, game developers must weigh the feedback of beta testers with their own knowledge of what the game is and should be, as well as how they expect other player groups to experience the game. But it's key to note that even players that deemed themselves newbies were confident in taking ownership of the game experience, as well as questioning developer assertions that the game was ready for public release and worrying about a potential resulting failure to capture needed revenues.

Going Live: Faunasphere Hatches

On August 14, 2009, Big Fish officially launched *Faunasphere* and opened the game to anyone who wished to play. Those who had not yet been selected for the beta eagerly signed up, and the world grew in population. Yet although the game was new to those who had just created an account, the beta testing community had helped to frame the game in particular ways, such that initial encounters with *Faunasphere* and its players were quite distinct from the experiences of other MMOGs. In particular, a "culture of niceness" had emerged in the game, which was to have important effects on the larger player community.

Because so many beta players of *Faunasphere* were new to MMOGs, they were understandably unaware of many conventions of online games. Likewise, the detailed and (often poorly) documented fiction of the world was likely confusing to almost all players. For example, players could feed their fauna food that would increase their mood and let them engage in more activities, yet the optimal foods differed for each fauna type, and it was nonobvious in gameplay how to identify and locate them. On the other hand, giving a fauna a type of food it did not like would decrease its happiness and reduce the amount of activity it could engage in, and each food type would affect different fauna differently. During the game, a player could hover his or her mouse cursor over a food item, which would cause a lengthy description to pop up. At the bottom, there would

be a number of smiling faces or frowning faces, which represented how the fauna the player was using felt about that food. The best foods were "6 smiley foods." As with other foods, these differed by fauna type, with chompers (alligators) liking cuddyrice, hoofers (horses) preferring pul- lyleaf, and sniffers (dogs) enjoying bacoberries the most. On the other hand, feeding a fauna something it did not like would cause its happiness to decrease, so players were required to be familiar with a fairly complex system just to keep their fauna happy. To give a sense of the scale of this system, the fansite wiki lists 210 kinds of basic food, which could be found in the game world; 117 kinds of advanced food, which could be found in the world or made by combining two basic foods, the latter requiring the player to have a "combining basin"; and 17 premium foods, which were made by combining an advanced food with a "bakerstone" or a "cool- stone," requiring the player to have a "crock." The subsequent premium food would then have one of two temperatures and one of four flavors, all affecting how different fauna types felt about it. Clearly, players were not able to intuit such knowledge but were forced to research and experiment, and then they began to pool their resources and information.

During the beta test period, such factors led players to band together to figure out the space and how to engage in enjoyable play. And true to their roots on the Big Fish forums, the players were more often than not exceed- ingly helpful to one another as they learned how to play. What began as a "pay it forward" mentality in the beta period carried over into the game's public release. As Jolene explained, her experience with players who had been in the beta set the tone and expectations for how she should play the game in general: "One of the first players I met in-game . . . gave me 300 grass blocks to build with, and food for my starter dog. I thought that's how everyone played, so I did the same thing when I'd meet new players in the game, in the beginning."

In addition to gifting and sharing information, the beta players had also developed conventions for gameplay that might seem anathema to a more traditional MMOG player. Perhaps taking the idea of "ninja-looting" to its extreme, many beta players went to great lengths to ensure that they did not encroach on other players' pollution-zapping and root-digging activities, as only a set number of rewards would result from zapping and digging. But because the game was designed in a low-resolution Iso- metric 3D and players would point and click to where they wanted their fauna to move, it was sometimes difficult to see if another player's fauna was nearby, especially if part of the pollution pile was on the edge of the player's screen. Yet players habitually tried to ensure they did not

"accidentally" zap the pollution that another fauna was zapping (unless of course help was explicitly requested). For example, a survey respondent explained, "I don't like going into the worlds and running around in circles with the hope there might be a block of pollution to zap. And, if I do find some to zap, I need to double check to make sure someone else is not already zapping the block from someplace off my screens display." This expectation of self-monitoring had become routine in the game's beta, such that regular players expressed frustration when others did not observe this custom. Rachel, for example, spoke for many players who felt that upon public release of the game "rude behavior was eminent and often hard to ignore. People zapping the block you were already zapping."

Beta players of *Faunasphere* took a direction quite different from new players of other MMOGs, such as *EVE Online* in particular. As Paul explains, the experience of learning *EVE* is immensely challenging, where players are confronted with "frequently incomplete instructions that infuse the early game experience with a level of frustration that borders on keyboard throwing."[8] Similar to *Faunasphere*, *EVE* is a game where players cannot rely on game tutorials or instructions but instead must help one another learn to play the game. There are many player academies, guides, and sites available to help new players, but *EVE* is also a place where "many players will shoot you down in a heartbeat."[9] To succeed in *EVE*, players need to develop a thick skin and accept the inevitability of death along with some kindness from strangers. To succeed in *Faunasphere*, players needed to not only take advantage of the help available from fellow players but also embrace the norm of sharing and generosity that earlier players had established. Unless they did so, players were likely met with hostility or suspicion.

Facebook Launch: "They Run in Packs . . .
like Gangsters after Vulnerable Victims"

Although the larger player base that resulted following *Faunasphere*'s official launch allowed more individuals into the game who might not be familiar with the beta testers' norms, a firestorm erupted when *Faunasphere* was ported to Facebook. Despite assurances from Big Fish that the game was still playable via the web, some players expressed dissatisfaction with the change. The experience of playing the game via Facebook was slightly different—there were now gifts available to send to other players that could not be found via the browser-based version of the game. So if players wished to give them, they needed to play via Facebook. Some

Faunasphere players did not have Facebook accounts and did not wish to sign up—they felt that Facebook cared little about members' privacy concerns. While some players never did make the switch, others did so via the creation of fake Facebook accounts, created primarily for playing *Faunasphere*. Players using accounts in such ways kept personal information on the accounts to an absolute minimum. In that way, they could gain the benefits given to players using Facebook while minimizing their use of (and potential information sharing via) the larger social network service.

But much more important and corrosive to the community's sense of itself was the belief that Facebook players were somehow different from those who had played the game prior to that point. Many of the early players were fellow Big Fish customers and shared a similar demographic profile. While there was no easy way to identify players in the game as coming from one location or another, troublesome players were often linked with the Facebook expansion. As Lucy made clear, "The game did seem to go downhill after the Facebook launch . . . I never saw one incident of rudeness or the 'gimme/I want' brigade until after the FB launch." Here Lucy is also alluding to the perception that Facebook players often demanded free items from other players, which we discuss in further detail later in this chapter.

One of the central goals of taking *Faunasphere* to Facebook was to increase the number of players (and even more critically, paying players) in the game. As in most MMOGs, increased growth can be a double-edged sword. More players meant more revenue for updated content as well as a larger community where players could interact, make friends, and socialize. Yet avoiding overpopulation of worlds is a tricky endeavor—and many *Faunasphere* players felt "their" world was increasingly overcrowded, rather than hosting a comfortable population. Much like the original players of *There* when Uruvians arrived after the closure of *Uru*, the original *Faunasphere* caretakers felt as if an invading force had landed in their virtual playground.[10] The growing number of players led to increased competition for the (relatively) scarce resources in the game, such as pollution to zap and roots to dig up. And many new players appeared ignorant of the conventions established for play. The original caretakers might eventually have accepted the growing numbers of new occupants, except for one key issue—the newcomers did not appear to know or respect the early rules and customs created by the beta players.

Despite the perhaps rosy glow of nostalgia for the "good old days," early reports of playing *Faunasphere* from the Big Fish forums do indicate players were happy to help one another learn how to play the game. This

was likely due in part to the friendly community nature already established on the Big Fish forums—these were individuals who were already somewhat familiar with one another and had a good time socializing and offering one another advice on how to play various games. It must have seemed a logical assumption to them that in a new game, everyone (or most everyone) would work together to figure things out and have the most enjoyable experience possible. Indeed, enjoyment for many of these players came in part through helping one another out.

Yet with the opening of the game on Facebook, many newer players joined the game who had not been socialized into the norms of either the Big Fish forums or the beta players. What this meant in practice was that established players found themselves suddenly confronted with "many rude people, begging for stuff, following players and call them names . . . the only possible chat now is about what we can give to new players and what &$#* we are, if we don't give them what they want." One player summed up how many felt overall: "It seems as though everything is a fight. I am tired of having to compete for every little thing (if anything is even left) and defer to extremely competitive, rude, greedy players that have no idea what the heart of the game should/could be."

Beyond fighting over resources, many players were alarmed to discover that newer players would simply demand items or virtual currency from them in chat or private messaging, without even saying hello. Because *Faunasphere* revolved around breeding and hatching fauna, one of the most common activities in the game was trading or selling eggs. In the early days of the game, many players freely traded eggs with one another, provided politeness norms were observed. As Denise explained, "In FS, we didn't have to beg our neighbors for every item to complete a goal. There was a thread in the forums that you could go and ask, if you were having a really hard time with a goal." In contrast, newer players either did not know about such resources or didn't care. Jolene explained that although begging was present prior to the Facebook launch, it definitely became more of an issue after that: "Before it went to Facebook, there were a handful of players that would run up to you and demand 'gimme eggs' 'gimme Bux' 'gimme gimme, gimme everything' and some would follow you around demanding and calling you names if you refused. The language would get progressively worse as you ignored them, until you blocked them so you couldn't see what they were saying. After they opened it on Facebook, it went from one or two a day like that to dozens."

While it is impossible for us to quantify how this impacted the community as well as the actual frequency of such events, players reported to

us that some of them changed their play styles or frequencies after witnessing such occurrences—blocking chat with all newcomers, no longer helping strangers, or logging in less frequently or in off hours in order to play. Some players did say they had quit the game or knew of those who did, and there were periodic forum threads about long-standing players leaving the game.

Of course, some players who joined via Facebook were "properly" socialized into the game and had similar negative encounters with other Facebook players. And we would be remiss if we didn't point out that not all players disliked or dismissed "Facebook players." Certainly many Facebook players did not see themselves this way, and other older players pointed to happy interactions they had had with newer (and younger) players. Yet overall the culture of the game was ripe for a clash with the culture of Facebook game players, and it led to much tension and unhappiness—something that we'll take up in much more detail in chapter 3.

Backlash against the Betas

Although the majority of this chapter has discussed how beta (and then Big Fish) players helped to set the tone for the *Faunasphere* community, we need to discuss another side of the story—how newer players reacted to the beta players. For although most beta players saw themselves as friendly and welcoming, happy to instruct others in how to play, some newer players interpreted the words and deeds of beta players as those of "a closed elite group."

Many potential players were eager to take part in the beta testing of *Faunasphere*, and those chosen as beta players likely saw themselves as fulfilling a special role. Tasked with finding bugs and figuring out gameplay, beta players had been expected from the beginning to vocalize their concerns and interests in order to improve the game. Indeed many of them saw it as a special role to play, and they felt Big Fish was depending on them to help the game improve. And upon the game's launch, it likely seemed natural that those already playing could serve as experts to those just starting out—indeed they had already accumulated a significant amount of gaming capital from their months spent as caretakers and world builders.[11] And many newer players did appreciate their help and advice, quickly and happily turning to them to figure out how to breed fauna and decorate their spheres.

Yet a small minority of players was not so charitable—feeling instead that the help and advice offered by beta players impinged on how they

wished to play the game and that betas were not welcoming to newer players. For example, in our survey, one player explained, "As people gain more experience with this game, I think they lose sight of what it was like to be new. Older players do not seem to realize that they have developed extraneous 'rules' regarding etiquette that the new players do not know." Another was not so generous, arguing that beta players believed that "you should always greet first and do things my way and why aren't you more like I am? My rules rule and you are stupid."

Similarly, some players felt that despite claims of a warm welcome, many beta players were closed off and suspicious of newer players. One wrote, "The beta testers tend to think that they are better than anyone else," and another wrote that they were "very much a clique that if you weren't there from the beginning you're not welcome." One particularly insightful beta player, Lionheart, felt that some of her fellow betas "were negative toward new players as they saw them as a threat."

Of course, many beta players also told us they were unhappy with the newer players in the game, so it is not surprising that some newer players would sense this dislike and interpret it this way, with valid reasoning. But it does point to the dangers of creating close communities in beta testing periods: If newer players are not felt to be equal to those who were there from the beginning, and feel that other players are dictating the only acceptable way to play, the overall community suffers. As Paul found with his study of theorycrafters, tensions can emerge when one subset of players determines the "right" or "correct" way to play a game and other players feel their ways are not valued.[12] In the case of *Faunasphere*, it is ironic that the initially correct way to play as developed by the betas was by valuing friendliness and sharing, and through the ensuing concretization of those behavioral expectations into norms and rules, those positive values became associated with exclusivity and hostility.

The Impact of Rules and Fiction on Play Styles and Player Attitudes

Player communities like the caretakers in *Faunasphere* are dynamic entities that coalesce and evolve over time. The individuals that make up such communities and their demographic profiles, past play histories, and play styles, as well as experiences with each other in and out of the game, all play key roles in making the group what it is, throughout its lifespan. Of course, the game itself and the developer's responses to those communities are pivotal as well, particularly in the early stages of a game's life. With MMOGs in particular, how players react to a game and to one another

while it is still in development can be key factors not only in player enjoyment but in the future success of a game. Disgruntled beta testers can ruin a game's launch, or conversely, delighted players can help drive subscriptions. Yet as we've discussed here, beta players and their influence extend far beyond the testing period, ultimately shaping larger player norms and expectations as well as helping or hindering community formation and a sense of what a game "is" or "should be."

Of course, beta communities do not spring fully formed from player signups, nor do they leave aside all prior interests and expectations when playing a game. But in addition to their own preferences and hopes, the game itself is an important guiding force shaping their behavior. For example, Taylor has described how social norms in *EverQuest* changed as the result of changes in the game's economy and transportation systems.[13] Writing more generally, Pearce has shown how the structure of a virtual world influences the cultures that emerge and the cultures of incoming communities.[14] In this section, we will detail a few of the design decisions in *Faunasphere* that likely impacted how the beta community responded to the game as well as to each other. Many of those decisions worked to shape the particular community that resulted. Thus the rules and fiction conspired to create a particular type of caretaker and a larger form of community.[15]

Combat and Grouping

Perhaps the major choice *Faunasphere*'s designers made that shaped the beta and then open community was not only the lack of player-versus-player combat but the lack of killing and violence in general. Players could employ their fauna to "zap" (clean) pollution, and doing so yielded experience and items that were useful for the player. But there were no free-roaming "mobs" in *Faunasphere*, and while some pollution might attack a nearby player, fauna could simply move away if the caretaker did not wish to engage. Further, although zapping was a useful activity for advancement, it was not designed as the central activity for players to engage in—much more attention was paid to activities including completing goals, building personal spheres, and hatching fauna.

What this meant was that a mechanic central to almost all MMOGs—combat—was a minor element of *Faunasphere*. This had several ramifications on the beta (and later full) player community. First, players did not concentrate on fighting or killing in the game, and teaming up to do so was not particularly helpful. Thus competition between players, in terms of either player-versus-player combat or even competition for

"claiming" particular mobs, was not an issue. Instead, players were free to do as they wished with respect to zapping. Indeed, beta players were so noncompetitive in this regard that they discussed etiquette rules on the forums, encouraging all players to not hog resources or start zapping or digging an item or mob that another player was already engaged with. Thus a major point of contention in many MMOGs—claiming scarce resources—was not deemed an issue at all by *Faunasphere*'s beta players.

In counterpoint, combat is also a way that many MMOGs encourage players to group together, to fight mobs they could not kill alone. Most fantasy-themed MMOGs feature player groups such as parties, raids, teams, and guilds in order to facilitate that work. While many players also use those groups to socialize, it's key to realize how central combat is to most game grouping. Zapping in *Faunasphere* was never designed as a group activity, and so no grouping by beta players occurred—instead players went in the opposite direction, being overly careful *not* to interrupt another player's zapping. And with no other reason designed into the game to group together (and lacking any formal grouping functionality), beta players instead approached the game as singular players with friend lists who might gather together in one space to socialize, but with no particular need to do so.

Happiness Is a Warm Taterbean

When fauna did battle with pollution, they gradually would become fatigued and unhappy, eventually falling asleep and needing to be returned to their home sphere in order to restore their health and mood. However, players were given the option to feed various foods to their fauna in order to keep them alert and likewise could create dens for them in order to make them happier and thus able to engage in more activities for a greater period of time. When the beta period began, there were many types of food and den material available for players to use that resulted in different levels of rest and happiness (as well as fatigue and unhappiness), yet no instructions on which items were the best for the varied fauna a player might wish to aid. It was thus possible to build a den that would make one's fauna *less* happy by sleeping in it (as one of the authors did). Players quickly realized they would need to pool their resources and share information about what food and items worked best for each particular fauna. Thus players created websites, posted in forums, and generally chatted about how best to take care of their fauna. And because many of the items needed to feed or den fauna were common, most players shared actual

resources along with the basic information. This activity was very similar to the decoding and sharing of food-related information discussed before.

Yet many games begin with cryptic instructions and less-than-clear guidelines for how to play at all—let alone optimal ways to do so. What's key here to guiding the future of a game and its community is the particular discursive construction of such items and their use. Just as fauna did not kill anything, neither did they need to collect gear or items to make them more efficient combat machines. Instead their food and den material were designed to increase their mood and make them happier. Discursively the game designers presented attributes of the fauna and their activities within the world as positive. Happy fauna could be played with for longer. Beta players were encouraged to work hard to discover happiness formulas, to theorycraft (if they wished) their way to more "smilies" rather than greater attack potential. Drawing from the positive fictions of many casual games,[16] the construction of happiness and good moods in *Faunasphere* created an atmosphere perhaps more conducive to players' own happiness and contentment.

Monkey-Head Totems and Community Spirit

For players interested in creatively decorating their private spheres, the totem system was designed to allow access to rare or unique items. Players could earn a "totem" via a simple quest, after which they could place the totem in their private sphere. Totems were used to manufacture one of a dozen different elements that players could then donate to "community projects," which were essentially raffles for exclusive decorative items. While players might focus on generating items only from their own totem for donations, if they wished to have a better chance at winning the raffles, they needed to visit other players' totems and buy components from them as well. Players could only visit those players who were on their friend list, so the totem-focused player likely was intent on having many friends in the game.

While players might see the totems as resource generators, *Faunasphere*'s designers were using the scarcity created by the totem and community project system to try to encourage players to visit one another's spheres and to become "patrons" of one another. Thus Mia could buy all the stock of whatever widget Jason was selling, in order to donate it to a community project and have a chance to win a prize, but in order to do so they first had to be on each other's friend lists. Beta players developed lists on the forums of players and what their totems sold, so others could easily befriend and then gain access to needed elements.

Players could also leave a gift for another player at their totem with a note attached. Many players utilized this system as a way to announce that they had been to the totem and had become a patron of that player. Players could then take the gifts or leave them with the totem to be a continual reminder of who had visited, much like a guest book at a formal event. During the beta, motivated players were happy to share information about who had scarce or needed totem elements, and the system encouraged players to visit one another's spheres. As a byproduct, players also saw one another's decorating efforts and collected fauna. Such elements encouraged players to interact with one another in a way distinct from combat-themed MMOGs, where players must work together to defeat common foes. In some ways, the totems functioned as generators of player-crafted items put on auction (similar to most MMOGs), but the creativity of gifting and witnessing one another's spaces created more positive community elements based on crafting and decorating.

Hatching Fauna

One major activity in *Faunasphere* was breeding fauna, and players were quite intent on figuring out how the system worked from the early stages of the game. In most traditional MMOGs, players grind to gain experience to kill stronger monsters, in order to get more levels and better gear to kill even stronger monsters. At some point, a level cap is reached, but players continue to play, mostly questing for "epic loot" (powerful items) or various game rewards that show their status or achievements and make their work easier. In *Faunasphere,* players could zap pollution or complete goals to gain experience, but when enough experience was earned for the fauna to gain a level, instead of being able to kill stronger monsters (or more deadly pollution), it would lay an egg, which could be used to hatch new fauna.

However, eggs were ideally traded or sold, as the design of the game encouraged players to trade or share eggs with one another: crossbreeding was the key to variations and hatching new fauna. Although there was no real science behind the system, there were both patterns and random elements, and these dynamics worked to keep players sharing information along with eggs in order to create new and different fauna. This randomness meant that an egg from one kind of fauna, when incubated by a different kind of fauna, could potentially produce a third kind of fauna. The game would not reward players who kept to themselves and only used their own eggs, as they would just hatch the same kind of fauna over

and over—the key was in diversification. Likewise, players who simply bought eggs from the marketplace would not know the specific histories attached to those eggs—only who was selling them. The most rewards would come to those who actively talked with other players, learning where eggs came from, what other combinations had been tried, fauna breeding histories, and what the other player might recommend. This system therefore encouraged players to actively share with one another and in their own words "pay it forward" via helpfulness and generosity.

It's also important to note that these new and rarer fauna were not more efficient pollution zappers or root diggers—they were simply different. Again, the fiction of the game world was designed to draw a different type of player—one interested in breeding animals, rather than killing monsters.

Hanging Out in Rock Garden

Finally, *Faunasphere*'s creators had also designed public spaces where players could congregate with their fauna and engage in public chats. This served several purposes. Because *Faunasphere* was a noncombatant world, there was no danger associated with gathering and so players felt safe doing so. It also served as a space to show off recently hatched fauna, particularly ones that might have an interesting or unique mutation. Given the game's ability to let players rapidly change the fauna they were "showing" (i.e., they did not have to log out and back into the game with a new avatar, like most MMOGs require), it was easy for players to show off and playfully share the fruits of their labor.

Likewise, the public spaces served as gathering points for players to undertake activities of their own. As with most beta versions of games, there was a relative dearth of content (particularly with respect to goals), and so players created their own content. Similar to Pearce's Uruvians who held play sessions and parades,[17] beta caretakers had Fauna Parades to show off their hatchlings and would likewise create games such as hide-and-seek for players to participate in. Given the small number of players in the beta test, it was easy for players to feel that they were getting to know a majority of those involved, and they would likely feel more motivated to participate with this "group of friends." Players could also talk about and share screenshots of past events in the game's forums, where they became an official part of the history of the game and a normal part of gameplay for later players.

To sum up then, certain design decisions made for *Faunasphere* helped to shape the player community in particular ways. The lack of combat, the

safety of the space, the need to share information about a complex world, the positive fiction, and the relative lack of structuring goals aside from breeding fauna all contributed to a space and a community that favored sharing and friendliness over competition and hoarding.

The End of the Good Old Days

The beta players of *Faunasphere* helped Big Fish Games smooth over problems and test the design of the game. They also helped us learn more about the importance of considering beta players in larger understandings of game-playing populations. But beta players themselves don't exist in a vacuum or spring from thin air without context or self-interest. A multitude of factors come together to create a beta player and a beta community, both of whom shape the larger player communities of MMOGs.

First, it may seem obvious to state this, but the design of MMOGs influences in subtle and not-so-subtle ways who will play the game, how they will play, and why they play. *Faunasphere* emphasized zapping pollution, completing goals, and breeding rare types of fauna. In comparison, *EVE Online* emphasizes space travel, mining, the accumulation of wealth, and an "anything goes" atmosphere. Each design decision that developers make helps define who will and will not find a game appealing. Likewise, those decisions can shape how players respond to the game—through the presence or absence of negative feedback, through grouping mechanics or their lack, and through how players are rewarded. The beta players of *Faunasphere* found a cheery world that allowed them to create, explore, and adopt virtual animals with people they already knew from the Big Fish game forums.

Second, even if developers give players a world and a set of rules, players will make of it what they please. As a result, who gets invited to take part in the early shaping of the game matters a great deal. Asking already-loyal players meant a more committed group of players for Big Fish than if the beta comprised strangers to casual games and the company. Creating a context for testing where players are asked to take on an important testing role and report back with problems created a sense of responsibility that players took seriously. They also found the game enjoyable and felt it was only fair to share those feelings with those still waiting to be invited to play. Those early beta players regularly reported back to nonbetas in Big Fish forums, not just providing a sneak peak but, perhaps more important, smoothing the way for a group unaccustomed to MMOGs and their style of play. Their early friendliness and camaraderie helped to further

shape the game space and what was done there (parades, hide-and-seek games) as well as to establish the particular norms of the community.

In the case of *Faunasphere*, those beta players created a sense of community based on specific values. They were committed to sharing information and help, creating a welcoming space for each other, and promoting a "pay it forward" mentality. In doing so, they helped define what it meant to be a *Faunasphere* player and a valued member of the *Faunasphere* community. Their early access to gaining gaming capital ensured they would be recognized as experts within the game, and they used their position to promote how they felt the game should be played. Of course, communities need outsiders to define who is inside or a part of the community, and in that the beta players had a part as well. The norms they developed meant that politeness was expected in all social interactions, pollution was "meant" to be zapped by only one player at a time, and one did not randomly ask strangers for items or help. Those who disagreed with such strictures were not "good" *Faunasphere* players—they were rude children used to the norms of Facebook gameplay. And for those who did disagree, beta players were an elitist group, intent on telling others how the game had to be played—much like the "Elitist Jerks" in *World of Warcraft*.[18]

"It Was Every Bit like a Small Town"

According to scientists who study the brain, the more a memory is accessed, the more greatly distorted it becomes.[19] The most accurate memory, ironically, is the one never actively remembered. In our research, we asked players to recount their memories of *Faunasphere*—its beta period, open phase, and up through the game's closure. Just as with all research of this kind, we are always at the mercy of players' abilities to recall events correctly, particularly when dealing with events that have concluded. Researchers who investigate the idea of collective memory argue that it is a way that groups construct a sense of identity for themselves, through the sharing and creation of a collective past. But the idea of collective memory has been poorly defined and loosely studied, giving us more of a general framework than a well-structured theory from which to draw for insights. Yet the idea is still useful for this project, we believe, by drawing a few more boundaries.

Two central questions arise from the work on collective memory that are key to consider for this project: Whose past is it, and which aspects are actually remembered and which are not? Harris, Paterson, and Kemp

ultimately believe that "socially shared memories may be less accurate than individual memories, but this should not necessarily be interpreted as a disadvantage of socially sharing memories, since accuracy often may not be the most important of social memory functions . . . sharing memories in a group means that the experiences of others may be adopted as our own and that the consequences of remembering with others are ongoing."[20]

If we believe that the beta players in *Faunasphere* were involved in constructing a world and a community, we should also recognize that building a history for that group and space was an important part of the process. In order to see themselves as a community, they had to envision themselves that way—as a small town, a tightly knit group that might disagree but who were fundamentally in agreement that the world of *Faunasphere* was a special place. Olick argues that in the creation of collective memories, it is usually the case that "accounts of *the* collective memory of any group or society are usually accounts of the memories of some subset of the group, particularly of those with access to the means of cultural production or whose opinions are more highly valued."[21] In terms of *Faunasphere* and other MMOGs, this means that the actions and remembrances of beta players likely have great importance in setting the context for a community to take hold and to remember itself. And with that power comes the ability to shape others' perceptions of how a game is properly played and who is a member of the group and who is not. Of course, no history is one sided, and we have discussed players who were opposed to such values and actions. In examining those separate stories, we see where the cracks in the larger story emerge—the fissures that expose the incompleteness of any community story. For researchers in our position—trying to understand community-defining events after the fact—this is the best we can do, we believe, as memories are always already suspect, fragile, and incomplete. This is not to say that these methods are unimportant, or the findings valueless, but rather that it is important to realize their uses and limitations. In the case of *Faunasphere*, what actually happened during the beta period made less of an impact than how the community understood what happened. Understanding the shortcomings of this method—that it reveals perceptions over facts—in actuality leads us to a more useful truth. For better or worse, the beta period had a profound impact on the *Faunasphere* community, and understanding it in the way the players did is essential to understanding *Faunasphere*.

To what extent this phenomenon does or might exist in other MMOGs and virtual worlds is beyond the scope of our project here. However, we want to briefly emphasize that *Faunasphere* had several factors that

we believe lead to the beta period playing such a prominent role. First, the game was in existence for less than two years, and as such, the beta period made up an abnormally large percentage of the game's overall lifespan. Second, the game was extremely small, and therefore beta players made up a substantial percentage of the player base (though admittedly more so prior to the Facebook launch). Last, much of the player base comprised a preexisting community of individuals with similar tastes and expectations. While we can only speculate, it seems reasonable to assume that had the game run longer, the importance of the beta players and their culture would have continued to diminish. It also seems likely that had the beta testers been drawn from a pool featuring players with a more diverse background, the culture they created may have been more open to different play styles. How these forces instantiate and shape the cultures in future MMOGs should prove a rich topic for scholars going forward.

Shifting Platforms
and Troubled Ground

Faunasphere *and Facebook*

Rudeness, it didn't really happen much until Facebook entered.
That in my humble opinion was the downfall of the game.

—JACKIE

Even as beta players performed a key role in establishing the atmosphere and player community in *Faunasphere*, the platforms on which the game appeared also impacted how players engaged with the game and each other. *Faunasphere*'s initial launch as a stand-alone browser-based application drew its early players from Big Fish Games's existing pool of customers, who were already familiar with a web interface for finding and purchasing single-player casual games. That platform proved stable and relatively successful, yet it was quickly supplemented via another platform—Facebook. It would be surprising if Big Fish Games had not planned that augmentation from the start, given Facebook's hundreds of millions of users and large game-playing population.

Faunasphere's public rollout on the web happened in August 2009, and it was only a matter of months until the game's Facebook launch in February 2010. While Big Fish continued to make both login options available (web and Facebook), they also worked to draw in new and existing *Faunasphere* players through the Facebook interface, using exclusive gifts only available via Facebook as a temptation. Other than that change, however, the game remained essentially the same, with only the location to find it being different. Yet even as players continued to zap pollution and hatch fauna in the same ways, the new platform was having noticeable effects within the game. Many original players reported being unhappy with the

launch and were not slow to voice their displeasures. Some were unsure how to play via Facebook or had technical difficulties doing so, many others were suspicious of Facebook as a company and so did not want to create an account with the service, and growing numbers were increasingly annoyed with the "Facebook sort" of player they were encountering after the game's integration.

Those player concerns and displeasures are markers or indications of the importance that a game platform holds in understanding the context of play. To better understand that discontent and how platforms played a role in it, this chapter investigates how *Faunasphere*'s migration to Facebook impacted the player community, including players' own beliefs about what kinds of individuals Facebook attracted, and why a "Facebook style of play" was so detrimental to the game. In doing so, we argue for the importance of not just seeing Facebook as a game platform but also recognizing how platforms are key sites to explore when thinking about player populations and how platforms help define them, how platforms work to determine certain gameplay expectations, and how clashes between differing expectations can cause trouble in player communities.

Platform Anxiety

Platforms are a relatively unexplored topic in game studies, with central contributions being the titles in the Platform Studies series from MIT Press edited by Nick Montfort and Ian Bogost.[1] Launching the series with their volume on the Atari VCS, they write that "platforms have been around for decades" but "little work has been done on how the hardware and software of platforms influences, facilitates, or constrains particular forms of computational expression."[2] Montfort and Bogost's book and series is a provocation to game studies scholars to focus on the platform as a meaningful site for study—one where code works to determine the contours of gamic expression. Their approach argues for exploration of the technical side of platforms, demonstrating how those affordances and constraints push us toward certain formations and not others. Another approach to platforms comes from Evans, Hagiu, and Schmalensee, who focus on software platforms rather than their hardware counterparts. They write that such platforms are most often operating systems, which do "everything from telling the microprocessor to turn switches on or off to providing a host of full-fledged software features for application developers that save them the time of writing those features themselves."[3] The authors go on to analyze many forms of operating system platforms, with one chapter devoted to home videogame consoles like the Sony PlayStation and

Microsoft Xbox that contain closed operating systems exclusive to those machines. In addition to pointing out key technical differences between the systems, they demonstrate how successful business strategies of companies like Sony or Nintendo normalize a particular revenue model for the console industry as a whole, such as the razor and blades model for selling consoles and games that run on them.

While the hardware platforms on which games run are an important consideration, we want to push the idea of platforms in a different direction and consider other aspects of such systems. Facebook is a platform in the same way an operating system like Microsoft Windows is: available on (or through) many different hardware configurations and a source of affordances and constraints. However, where Bogost and Montfort prioritize the hardware aspects of a platform, and Evans, Hagiu, and Schmalensee the software, here we will be emphasizing the social aspects of a platform: how users encounter it, the uses they make of it, and how their past experience shapes their future expectations.

Although home consoles are still a major source of revenue, the game industry now has many more sites where individuals will encounter games regularly. For example, Facebook has become a key site for the marketing and playing of games. Although it didn't begin as such, the social network site now boasts several hundred million users globally and has quickly become a node for online gameplay. Despite the vagaries of companies such as Zynga, Facebook continues to be a popular place for people to play titles such as *Candy Crush Saga*, and as of 2010 (when *Faunasphere* was launched there), 40 percent of the traffic to Facebook was to play games. The game library available on Facebook has diversified over time, although it was initially dominated by "build and harvest" games like *FarmVille*. Although there are also now different revenue models for games found on Facebook, many still adhere to a free-to-play or freemium model with optional purchases to advance in various ways. Early game offerings tended to build off casual game design elements with bright colors, positive fiction, and simple mechanics.[4] Most Facebook games feature asynchronous gameplay rather than real-time interaction, and the link to Facebook has meant that games are also linked to a person's profile and thus are not as anonymous as other online games might be. All these elements are key in defining Facebook as a platform for games that is quite different from the more traditional console platform, as this chapter will demonstrate.

In this chapter then, we are interested in exploring three areas: how videogame platforms coalesce particular player groups, communities, or demographics; how they push players toward certain styles of play; and how developers are likewise nudged toward certain types of game design

as opposed to others. While we will not address all these areas in equal depth in this chapter, we believe they are essential in understanding how players understand games and how platforms shape (and reshape) game communities in important ways.

From the Web to Facebook—Privacy versus Goodies

One of the more common elements appearing in social network games is gifts, including those that players can gain via regular gameplay sessions or send to and receive from friends. Games can offer players gifts that are minimal in their usefulness as well as gifts that are exclusive and of great value, gifts that reflect in some way the reputation of the giver, or gifts that are extremely useful for quests or goals.[5] It is safe to say that gifts are one element that nearly all Facebook games offer and one that *Faunasphere* had not contained as a browser-based game. Thus Big Fish added daily gifting as part of its Facebook integration, most likely in order to fit in with that design norm.

We cannot say for certain whether or not Big Fish Games wanted to entice existing *Faunasphere* players to use Facebook to play the game. But certainly some of those players felt pressured to make the switch because of the addition of gifting, and the presence of gifts contributed to tensions between those who played via Facebook and those who did not. At least some of the gifts were Facebook exclusive items and so weren't available via any other method. Others might have been available for purchase within the game, although some could be quite expensive, and thus the "exclusive" items became a topic of contention among some players. Finally, such gifts were available to all Facebook players, no matter if they had free or premium accounts, with the only qualifier being they needed a Facebook account in order to send or receive them. This was doubtlessly another source of tension, as players with premium accounts had heretofore enjoyed benefits (such as bux) inaccessible to free players.

Initially, some players were simply upset over what they felt was an unfair practice offered to those playing via Facebook rather than on the original website. Don related that he noticed "an outcry when it was realized that certain game objects were exclusive to Facebook players." Similarly, Beatrice explained that "many CTs [caretakers] were also resentful that players with Facebook connections or who played from Facebook got FREE items unavailable to other players. Paying players resented this." Although we didn't speak to any players who themselves stopped playing for this reason, some of our respondents told us of friends or other players

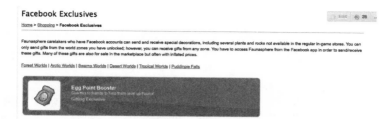

FIGURE 6. Taken from Faunasphere.wikispaces.com. That description reads: "*Faunasphere* caretakers who have Facebook accounts can send and receive special decorations, including several plants and rocks not available in the regular in-game stores. You can only send gifts from the world zones you have unlocked; however, you can receive gifts from any zone. You have to access *Faunasphere* from the Facebook app in order to send/receive these gifts. Many of these gifts are also for sale in the marketplace but often with inflated prices." Beneath the description is an example of one such item, the "Egg Point Booster." The description reads: "Give this to friends to help them level up Fauna!" and notes that this item is exclusively available as a gift.

who had quit the game because of gifts. Rachel told us that some players left the game after the Facebook launch in part because "it appeared as though the free players and kids were getting perks that they weren't."

Some original players continued to play via the web portal, but others did make the switch, either joining Facebook or using an already existing account to access the game. For example, Amber explained that she personally "caved in and joined Facebook to get in on the extras it offered." Likewise, Beatrice linked her preexisting Facebook account to her *Faunasphere* account, in part to gain access to those free gifts. And Don used his Facebook account in order to "send my FS/Facebook friends some exclusive gifts available only when played through Facebook." When asked why players were so upset about this shift, most cited unease with Facebook as a platform and its prior practices with regards to the privacy of its users. For them, the platform was unreliable due to these reasons and beyond gameplay. Don explained that "many people did not want to be part of Facebook because of its intrusiveness and oblivious attitude to personal privacy." Some players worked around this issue by creating "dummy" accounts that listed only a fake name like "Sunny Faunasphere" with a screenshot of their fauna as a profile picture. Several such players continue to use those accounts and contacted us with them when we were soliciting

interviews. In this way, they found a work-around that met their needs—access to gifts but limited access to the Facebook platform.

In addition to being a platform that generated issues of distrust and privacy concerns, Facebook was also an entirely new platform for other players, who were unfamiliar with social network sites and how they worked. In a forum thread on how to access the game via Facebook, several players also admitted to knowing little about how to set up a Facebook account or navigate its interface. Several posters were unsure how to access or activate *Faunasphere* from Facebook. Others were uncertain about the etiquette of Facebook, with one poster responding to a call for advice about creating a profile page with "I don't know—but I didn't want to be rude and just view your page. Good luck—I am too old to get involved with this." Clearly not everyone was comfortable with the new platform and did not see it as a simple interface to navigate. Others were wary of its use of their information and what might happen if they posted personal details on the site. Gradually the players who were interested figured out how best to use Facebook for their gameplay, but it's clear that it was not an easy or untroubled migration for all players. What even these brief stories of *Faunasphere*'s launch on Facebook suggest is that the platform was not welcomed by some of the game's existing players. The controversial history of Facebook itself played a role in its acceptance (or not) by existing *Faunasphere* players, and those concerns coupled with the creation of exclusive gifts for Facebook players generated the beginnings of tension within the larger player community.

Facebook's Games: Using Your Friends versus Grinding

While free gifts for playing via Facebook was an annoyance for some, a larger problem in the *Faunasphere* community centered on the differences in game design between *Faunasphere* and the many other games on the Facebook platform. Although there are many types of games that one can play there, at the point when *Faunasphere* linked with Facebook, Zynga was the predominant presence for games on the social network site. Their most popular games, such as *FarmVille* and *Cafeville*, centered on mechanics such as "build and harvest," which encouraged players to build up their friend networks and rely on those friends for gifts in order to advance. *FarmVille* and later games like it usually required players to acquire a certain number of friends as "neighbors" in order to expand the game's playable area, or else purchase that expansion via virtual currency. Likewise, games such as *Cafeville* offered players more advanced in-game

items to use that had to be first constructed, with many component pieces only available as gifts from friends. As such, Zynga's games relied on players continually asking friends for help of various sorts in order to advance and succeed or, if players did not have the requisite number of friends, to instead rely on purchasing virtual currency to do the same. Although it's now unremarkable to look back at this period as the start of the boom in social network games, it's important to situate the event historically. If, for example, *Faunasphere* had launched on Facebook before *FarmVille*, or concurrent with it (and before certain gameplay norms had taken hold), there may have been different responses to, and expectations of, the game by the Facebook audience. Instead, the historic position of *Faunasphere* post-*FarmVille* (and most likely relying on that popularity as a reason for its launch on Facebook) meant that many new players of the game would look at it through the lens of gameplay expectations developed in different sorts of games.

Ironically, much of early gameplay practice in *Faunasphere* depended on players helping one another—usually by giving one another eggs for crossbreeding fauna or different items in order to decorate personal spheres. And *Faunasphere* also allowed players to visit other players' personal spheres and help one another—usually by purchasing items from a totem or leaving a gift. Yet despite those surface similarities, tensions emerged when players that were more accustomed to games like *FarmVille* started to show up in *Faunasphere* and were particularly ignorant of the community norms that governed how interactions between players should proceed. As we've seen, game mechanics in typical social network games are more usually based on transactions rather than trust, and gameplay encourages viewing friends as utilitarian resources rather than as members of a larger community.[6]

Yet that was not how veteran *Faunasphere* players saw their game functioning. For them, the game was not about using one's friends but about paying it forward with like-minded others. Seasoned players began to object when they found that "people were more demanding, rude, and overall did not go along with the community spirit that was the cornerstone of FS in the beginning." More specifically, as Maria related, "whenever you went out into the main worlds . . . there were demands for items from all sides. It became so bad that there were people waiting by the gates to accost you when you came out of your house." Many of the players we talked with were very forthcoming about the "rude" players who demanded eggs, bux, or other items from them, usually without even a greeting or polite request. Some players such as Lucy told us, "I never saw one incident of

rudeness or the 'gimme/I want' brigade until after the Facebook launch."
Others felt that even direct requests were against the spirit of the game, as
one respondent mentioned in our survey, "I have met many new players
though that are very nice and appreciative of help freely offered. Others
think they should be able to 'ask and receive' items for free. Pushy, greedy,
won't listen to explanations, come right out and ask for eggs, lux, bux, etc.
You name it! Many just want the easy way out." What this indicates is a
clash of gameplay expectations—with Facebook players more used to the
utilitarian style of gameplay expected in games like *FarmVille*.

In some ways, the Facebook launch was a more extreme version of the
earlier opening of the game to the public. As we discussed in the previ-
ous chapter, the beta players had established a set of community norms
and expectations and were upset when new players did not heed them.
The same process repeated itself with the Facebook launch, but in our
responses, the complaints about Facebook players were much greater in
number and severity than complaints about pre-Facebook, nonbeta play-
ers. Although we have no means of comparing the number of new players
that joined with each "opening" of the game, our data suggests that the
Facebook launch saw much more communal friction.

While some players merely voiced their concerns and complaints about
these new players, others saw a link between other games played via Face-
book and these newer players. As Belle explained, despite the surface
similarities described before, *Faunasphere*'s gameplay—as established by
its player community—was a very different experience compared with
other types of Facebook games:

> I blame it on the FB games (ie, most all of them) that require begging for
> things to finish quests versus actually being able to "accomplish" quests
> without having to ask your friends for items. It was a culturally differ-
> ent model than what FS was promoting. FB games force you to have x
> number of neighbors before you can expand your cafe/farm/world, you
> have to ask your friends to send you items to complete most all of the
> quests because there is zero way to get them in game. FS was a game
> where you were supposed to work for things to accomplish goals. If
> someone gifted you something, it was out the goodness of their heart,
> not because you begged for the item. Most of us like the idea of a work
> ethic versus a beggar/gimme/entitlement ethic.

Other players made similar comments, suggesting that the style of
play that other Facebook games promoted led players to respond in ways
quite different from the caretakers of *Faunasphere*. For example, Katrina

explained that "the FB crowd is different in general. Those games demand begging. And so many people befriend without even trying to get to know one another. That's sad to me and not at all how I'm built." Others voiced similar explanations, with Puzzles suggesting that the predominance of a certain gameplay style led to a clash when "a whole 'generation' of players . . . [entered] the game, who were used to the traditional Facebook games where in effect you beg your friends for things, and they seemed to be unwilling to achieve any of the goals on their own." What such players describe is a challenge to a game community and its practices that were so carefully built during the beta period. While some players certainly encountered rude players after the game's public release (and before Facebook integration), the number of complaints was only magnified by Facebook integration and the play style that its games engendered. As a platform with a large number of similar games, Facebook had already begun to shape gameplay expectations in a certain way—toward transactions and away from interactions. That clashed with *Faunasphere* community norms and signaled to different players a division in how to play the game and what could or should be expected from others.

What we see as key here is one particular way that new players disrupted the game for more veteran players. Certainly new players can cause problems in any game, something that massively multiplayer online games (MMOGs) have constantly struggled with when companies add new geographic regions or new systems to a game's population. Yet when considering Facebook as a platform, we see how it has also developed a set of expectations or play norms for its games, based on the predominance of its early successful games. As Denise makes clear, when one plays games on Facebook, most of the time, "the community is more just a bunch of people that are forced to get together to make the goals work for each other. Like me, most of them have just added people that play the same games without having any real knowledge of who they are and they don't have much communication with each other unless it is concerned with game requests (begging)."

Such accounts suggest that two competing play styles became apparent with the Facebook integration of *Faunasphere*. One was based on building skill, putting in effort, and treating social relations as valuable and complex, while a second was based on gathering resources in as efficient a manner as possible. We should be careful here not to denigrate one style of play as compared to another—there was no inherently "right" or "wrong" way to play *Faunasphere*. But what is instead important to recognize is how Facebook was the locus for recognition of an emergent

play style—one applicable to "that crowd" who played Facebook games. To the detriment of *Faunasphere*'s original game community, it differed significantly in terms of its approach to gathering resources and social interactions. We should also take care to note that we are again relying on player recollections and beliefs about the game, which may differ based on the standpoint of the individual players. Although we did some observations within the game's space, we did not do extensive ethnographic work, and our limited view did not produce significant accounts one way or another concerning player interactions. But we believe that it's important to document how players perceived their experiences and made sense of them, accounting for what the majority reported as well as how minority groups saw similar situations. Whether or not Facebook actually caused the changes identified by the existing *Faunasphere* player community, the fact that they perceived it as doing so is an important finding in its own right. It points to the ways in which platforms shape player perceptions and expectations. Whether or not a given game is a "Facebook game" will affect how players approach it.

Hordes of Children and *FarmVille* Players

Just as *Faunasphere*'s players encountered a different sort of play *style* with the integration of Facebook, another important shift occurred in player *type*. There was no way to tell whether a player you encountered in the game was connecting to *Faunasphere* via Facebook or the web—no identifiers would mark a player as one type or another. Yet many players discerned a shift in player quality based on interactions they had or directly witnessed or heard about from others. While rudeness was the main issue, when pressed, individuals would respond that they were certain it was *children* who were the main problem with the game. Certainly some players were happy to encounter children in the game, and some reported playing with their own sons and daughters, who ranged in age from younger children to adult-aged sons and daughters. But many others did not want children in their game.

Setting aside behavioral issues, some players were simply upset that children were present in the game space at all and felt betrayed by Big Fish Games—they felt that the game was originally addressed to their target demographic and not the youth market. And according to the game's original terms of use (TOU), they were correct in the assumption that players needed to be adults, as according to the TOU, "*Faunasphere* requires all users to be over the age of eighteen."[7] One respondent to our survey related

that "as beta we were under the impression it was an adult game. We were told kids would not be playing," while another added, "I feel it was a mistake to allow children in to play as the TOS/TOU are too vague and most under 18s do not understand the concept of the intended community." One respondent put it succinctly, arguing that "I'm now an empty nester, spent most of my adult life very involved with my kids, their school and friends. It's now my time to be around adults. And, I thought I was going to find that within this game." We can see in such responses traces of the "time for me" attitude that Janice Radway discovered in readers of romance novels several decades ago.[8] Radway posited that for many women, even when they were reading novels filled with patriarchal themes, the *act* of reading was a site of resistance (however modest)—a way for women to claim time for themselves apart from their roles as mothers and wives. We noticed the same elements at work in some *Faunasphere* players—an attitude that this was not a space for the caretaking of children but instead a place for adult interaction, for time for one's self as a person, a friend, and a community member rather than for traditional familial roles.

And many more simply did not want children around, particularly those that were ill-behaved. Many respondents told us stories of rude children that engaged in disruptive behaviors while in *Faunasphere*. Katrina told us that after the Facebook integration, "there were a lot of kids (and some adults who acted like kids) who were pushy, ungrateful and begging." Katrina clarified that it wasn't simply kids who were the problem, but the culture of Facebook gameplay. But others were more specific in linking a player's age to their behavior. Caroline told us that "they didn't have any real understanding of the game, and didn't particularly want to know either. Many of them were well under the age, and didn't have the language skills (some in the 6–8 year old range) to be playing the game properly." Similarly, Patty felt that "when kids started playing in summer of 2010 that was hard because they play so different than the adults do. Most of us are moms in our 40s and above. We chat, help each other and talk about our kids, grandkids and pets. The younger players just want you to give them things and do things for them."

Responses like this point to the difficulties that players can have when a player community diversifies and norms for play styles and social interactions are challenged. What is particularly relevant about this case is how younger players are linked with Facebook as their point of origin. Many other researchers have found that when an established player community is confronted by new and potentially disruptive players, charges of them being "poorly behaved children" or "14 years old" are quite common.[9]

Likewise, Taylor found in *EverQuest* that the activities of power gamers, who sought to optimize their play in various ways, often brought about accusations of cheating or poor play from other players who did not see that play style as desirable or valid.[10] In that sense, *Faunasphere*'s original player community is no different from other game communities we have seen before, despite being largely female rather than male in composition. Yet does gender matter in this instance?

As mentioned previously, *Faunasphere* presents players with a game fiction that is centered on the caretaking of animals, breeding them as well as decorating home-like spaces. We will discuss in more detail in chapter 5 the complex relationships that players formed with their fauna, but here it is enough to say that the game's fiction was one largely dedicated to care, creativity, and achievement, rather than killing or direct competition. In our introduction, we briefly addressed the potentially gendered nature of the game's design, but we also argued against making facile connections between that design and resulting player activities. Certainly for this group of players, the fiction was appealing, but we can't say it was a universally popular option for all female gamers, as the game did not garner a high population of players—at least not high enough to make it viable for continued operation.

But given the caretaker role the game offered, and the largely adult female population of the game's player base, one preferred reading of the space would be that it encouraged players to act in ways traditionally defined as feminine—such as nurturing and welcoming—with respect to other players as well as to the game's fauna. And initially, at least in the beta, that's what happened. Players largely came together to help one another and establish a community.

Yet that supposedly feminine-gendered attitude hit a wall when confronted with a new type of player—the ignorant and rude player who did not want to be told how to play the game. And in that instance, most players rejected traditional gendered norms for their behavior and reasserted their interests in having a space of their own, apart from children or teenagers. For many of those players, that time was set aside as "for oneself" or "for adults." It was a space specifically designated for leisure and enjoyment, possibly with family members included but just as possibly without them.

Rather than seeing themselves as mothers or caretakers, they specifically rejected those roles in relation to other burdensome players. As Lucy explained to us, "There was also supposed to be a rule about younger players only playing while under adult supervision, but it quickly became

clear that we were the adult supervision, but if anyone complained about 'babysitting' young players, it seemed to be ignored." Another respondent to the survey was even more direct, stating that new *Faunasphere* players were "often children, they harass older players and we're expected to babysit them because you people [Big Fish Games] decided to advertise all over Facebook and attract that sort over here."

In short, many (female) players were angry over the "invasion" of their space and the shifting nature of the player community. Norms of appropriate feminine behavior fell away and were replaced by calls for "our game" and "our space" to be reinstated. Such activities force us to reconsider how even the most carefully constructed gendered spaces can fail to shape behavior, with female players in this case very forcefully demanding a space with other adults and rejecting another type of caretaking role that they felt was being imposed on them.

The second important element of this player disruption is evident in the quote just mentioned. Just as it was "rude children" and "beggars" that disrupted the game, many players were insistent that it was "that sort" of player to blame—those from Facebook. As we discussed before, some players did draw the link between the changing styles of play in *Faunasphere* and those encouraged by games on Facebook, but most players simply elided the distinctions, and the "Facebook player" came into being. Even as a few players tried to defend themselves—"We are nice people in Facebook. Really we are they make us out to be bad people"—many more were insistent that Facebook players were to blame for the game's ills. Most of the time, "Facebook players" were equivalent to children, although a few respondents did mention Facebook in regards to players with free accounts or those used to the culture of games like *FarmVille*.

It's curious that many players never questioned these assumptions about Facebook players—for example, the age of players—as Facebook terms of service limit accounts to those thirteen years of age or older. Of course, functionally that is difficult to enforce, but for most players, that discrepancy was never mentioned. Instead, a new group was formulated in the minds of early players—Facebook players—who were qualitatively different from traditional *Faunasphere* players. Just as with the beta period, an insider/outsider identity was constructed, although in this case, there was no way to immediately identify a player as a Facebook or non-Facebook user. And indeed, many original *Faunasphere* players created their own Facebook accounts in order to gain access to certain gifts. Although they did in the process technically become "Facebook players," they would not have associated themselves with that term or that identity. Instead it

became (and remains) an imagined or fictive identity used to define and label the type of player deemed troublesome or disruptive to the original goals of the *Faunasphere* community.

Returning to the issue of platforms, we see more evidence of a "Facebook player" being called into play. Obviously a straw player, the term still has resonance for what it does *not* claim to be—it is not a player that is an adult, polite, or engaged in more than surface elements of achievement in a game. Yet there is still some truth to the category and therefore some evidence that just as new game platforms can create expectations for gameplay elements (such as gifts), so too new game platforms, coupled with a predominance of certain types of games, can push players toward a certain style of play and a certain attitude toward one another. While Zynga was obviously a key element in shaping this style of play, over time their design decisions dispersed outward, into more and more games that appeared on Facebook. And in the process, the platform became as much (if not more so) associated with how one plays games on Facebook, rather than simply how Zynga games are designed. And so if most games on Facebook (at a particular point in time) reward resource gathering and treating other players as gateways to items, then most players will optimize for resource gathering and shallow interactions. Of course, there is always room for alternative and oppositional play, but the way a game sets its rewards will push play populations in certain directions. When many games do the same thing and it becomes associated with the platform on which it occurs, clashes will occur if a game tries to oppose this trend.

Implications for Platform Studies

We began this chapter intent on exploring several questions related to *Faunasphere*'s launch on Facebook: how videogame platforms coalesce particular player groups, communities, or demographics; how they push players toward certain styles of play; and how developers are likewise nudged toward certain types of game design as opposed to others. In exploring how Big Fish handled the launch of *Faunasphere* on Facebook and how players reacted and adapted, we can see the importance of the platform in shaping play and player communities.

It's key to note that upon *Faunasphere*'s migration to Facebook, Big Fish felt compelled to integrate a gifting mechanic into the game that strongly resembled elements of games from Zynga and other social network game developers. Gifting worked to reward regular logins and

probably made the game seem more familiar to newer Facebook players who were already well acquainted with such game elements. Yet the practice caused dissention among veteran players, who were suspicious of Facebook itself, were unsure how to use it, or simply believed that newer players were getting game items they were not. Big Fish's decision to make *Faunasphere* a more recognizable game for the platform thus ultimately caused a certain degree of trouble, as some players did not welcome that integration. It's also an open question whether or not the game's designers wanted to make such changes, if they were put in to draw existing Facebook players, or if they were seen as easy methods to improve player retention. Either way, the dominance of the gifting mechanic across Facebook was too strong to ignore, and *Faunasphere* players were suddenly confronted with the prospect of gifts and how to manage them and their circulation among players and in the game.

That change also points to the sway that platform expectations bring to game design. Sometimes platform holders dictate game design elements, such as when Nintendo regularly reviewed game content for the NES and when Microsoft decreed that games developed for the Xbox 360 needed to include a certain number of achievements. Yet here the case is slightly different—Facebook had no requirement for gifting to be part of its games, yet the mechanic had become so pervasive and thus expected[11] that *Faunasphere*'s developers added it as a feature during the platform migration. Other elements were transferred without issue, such as the freemium model, which was common across many games on Facebook at the time. Because *Faunasphere* was ultimately unsuccessful, it is hard to evaluate to what extent these changes were effective. It seems probable that Big Fish Games saw Facebook integration as a way to increase their subscriber base, but whether adding elements that fit *Faunasphere* into the Facebook game mold helped or hindered that project, we cannot say.

Finally, the move to Facebook was another key moment (following the construction of the beta community) for how players defined proper gameplay and the larger game community. The clash of styles that veteran players reported came in part from individuals used to a certain paradigm—the "build and harvest" games made popular by Zynga and then copied by other developers. The "pay it forward, please and thank you" play style carefully built by web-based *Faunasphere* players was met head on by players used to Facebook games, who understood games on the platform as resource-gathering spaces and other players as tools to acquire what one needed. Reciprocity might be helpful but was not necessary, and deep social ties were extraneous to the experience. Here

we can see how evolving game platform expectations were brought into relief when a different set of standards emerged. However, veteran *Faunasphere* players could not counter the predominance of the Facebook model, and so they either adapted, hid themselves away among friends, or quit the game.

What can we take from this in furthering the field of platform studies? First, it is valuable to study the social conventions and design expectations that evolve along with a platform. Such elements are deeply influential in shaping what players see as acceptable or unacceptable play behaviors in particular spaces. Second, although we have made the case that certain designs and play styles might sit well on certain platforms, we should not draw conclusions about the identities of the *players* we are studying. While those players may indeed play a certain way in *FarmVille* or *Faunasphere*, those same players may have different expectations for play, and different play styles, when or if they play on an Xbox 360 or a Wii and with different people. Platforms may certainly shape design and behavior within their spaces, but players can and do cross different platforms, try different games, and behave in a variety of ways in different contexts. While many of *Faunasphere*'s players were new to the MMOG genre, others were not, and many did play other types of digital games. Just as the players themselves changed their play styles and frequencies over the lifespan of the game, we cannot essentialize their play in *Faunasphere* as the only way they expressed themselves across different games. This suggests that while certain platforms may indeed be attractive to certain types of players, players themselves are often not faithful to a single platform, and to reduce them to such is to mischaracterize their activities.

The End of the World

On March 15, 2011, at 1:11 p.m. EST, residents of *Faunasphere* saw a network disconnect error message flash on their screens. Big Fish Games had pulled the plug on *Faunasphere*. Shortly after the error message appeared, players gathered in self-created forums and a Facebook group (all set up in advance) to express their grief, share memories, and decide on what they would do next. Big Fish Games had given them a month's notice of the world's impending closure (or "sunset" as such closures are called in the game industry), and so players were able to gather, commiserate, and plan their next steps. This last month marked the third major transition in *Faunasphere*: first was the opening of the game beyond beta players, then the Facebook launch, and finally the closure announcement. Each of these transitions brought with them significant changes to the *Faunasphere* community. In this chapter, we examine the impact of this final transition.

What happened during that last month in *Faunasphere*? How did players react to the closure of the game and the loss of their virtual assets, as well as the ending of an important activity? Did their play styles change at all, and if so, how? And what can those reactions tell us about virtual worlds and their residents, players and their avatars, as well as other game artifacts? Most research that studies the players of online games assumes a timeless place, one without a beginning or ending point. Rather than seeing play as occurring within the context of a particular game with its own specific timeline and history, much research conceptualizes play as somehow adrift of that grounding. In contrast, this chapter explores the answers to the questions just posed, through time spent in the game during its last days, via interviews with former players as well as through analysis of forum and group discussions. Although many massively multiplayer online games (MMOGs) have shut down, many more continue to open and age, and game studies scholars know very little about the end

of the lifespan for such spaces, particularly how players negotiate and participate in such closures. In this chapter, we recount the closing of *Faunasphere*, from the initial announcement up through the days immediately following the closure.

As we have noted throughout this book, *Faunasphere* was unlike other MMOGs in many ways. One significant difference important to this chapter is that in *Faunasphere*, players were not instantiated in the world via their fauna. Rather, the game directly addressed the person playing as a "caretaker" who was only "in" the world via his or her mouse cursor. Thus fauna were not avatars in the traditional sense but closer to virtual pets through which players interacted with the world. We more fully discuss these ideas and their implications in chapter 5, but for now it is important to note that players were playing with, not as, their fauna.

Studying Game Closures

In order to gain a better sense of how *Faunasphere* players felt about the game's closure, we employed a mix of qualitative methods that allowed us to contrast how players described their experience with what we actually observed players doing. That comparative qualitative data also painted a much more dramatic and insightful picture than mere observation could have.

After the closure announcement, we began regularly reading several threads on the official forums to see how players were reacting. We also wanted to see if and how the community would organize means of communication postsunset; Big Fish Games had announced their intention to close the forums associated with the game as well. The two main groups that surfaced were the "Faunasphere Memories" Facebook group and the "Faunasphere Orphans" forum (independent of Big Fish Games's forum site), both of which were established by community members in advance of the close. We joined both groups to observe discussions and to recruit participants to complete an e-mail questionnaire about their activities in *Faunasphere* and what the game's closure meant to them. In doing so, we openly posted in forums about our past work on the game and our intent in gathering information from individuals.

We logged in to the game several hours before the scheduled sunset to conduct further observation, though at this stage, we refrained from interacting with other players apart from casual conversation or simple greetings. We were interested in what players were doing, what they were talking about, and noting where they were gathering. In the final few

hours, we observed a small group of roughly thirty players, including the forum moderators, gathered in the "Rock Garden," which was the game's main public space. Directly after the closure, we monitored the Facebook group Faunasphere Memories, which experienced a very high volume in the days immediately following the closure.

We then distributed a qualitative questionnaire to willing recruits, asking players to talk about how *Faunasphere* fit into their lives, how they felt about other players, and how they reacted to the closure. When necessary, we did follow-up questioning via e-mail to request further details or to clarify particular points that informants had made. Most respondents were quite eager to help, and in total, we received twenty-six responses of varying length and detail.

Studying the End of the World

We observed several stages that took place over the course of the final month and functioned together to constitute the end of *Faunasphere*. Those stages included the closure announcement, preclosure activities, the sunset event, and the game's decline. Each stage was characterized by both developer actions and specific player behavior, including how players were reacting to developer actions (or inactions) as well as players' subsequent actions and activities inside and outside the game space. Each is here summarized briefly before we explore each stage in depth.

Stage One, Closure Announcement, began on February 15, 2011, when Big Fish Games sent an e-mail to all *Faunasphere* players announcing the game's coming sunset. These e-mails were accompanied by postings in the official forums. Such notice is not unusual, as most virtual worlds announce their closures in advance of the event, allowing players some amount of time to prepare for the end; in the case of *Faunasphere,* players had one month. The official announcement is a key component of a closure because of how it frames the closure, through both what is said and what is unsaid, and it is vitally important with respect to player reactions and subsequent activities.

Stage Two, Preclosure Activities, was the period leading up to the actual sunset. During this stage, players negotiated their continued activities, made future plans, attempted to communicate with the game developers, and perhaps continued to play the game.

Stage Three, Sunset, included the final hours of the game and the actual moment when it was shut down. This stage featured increased activity in the game world for the final few hours of the game's existence. This was

followed by the final moment as the game shut down and then the aftermath in which players either gathered elsewhere (forums, games, chat, Facebook groups) or dispersed. This period can also be quite active as well, if players are intent on creating tributes to the game, on gathering together to reminisce, or on making plans about where to gather next. Players may also continue to lobby developers via e-mail, petitions, and other means.

The fourth and final stage is Decline, when interest in the game wanes. Some players continue their activities from the previous stage, while others move on—to either other games or other pursuits. There is no obvious end point for Decline; instead, it is mostly a long and slow descent into inactivity surrounding the game.

Although there hasn't been detailed academic study of MMOG closures, we believe that the closing of other online and persistent game worlds is likely to comprise similar stages, although more work will need to be done to determine if this is the case. In the following sections, we focus on each stage in turn, paying particular attention to how players of *Faunasphere* acted and reacted, to theorize what these actions might mean.

Stage One: Closure Announcement

On February 15, 2011, Big Fish Games sent an e-mail message to all *Faunasphere* players that announced, "It is with a heavy heart that we are letting you know that we will be phasing out *Faunasphere* beginning today and ending on March 15." It continued, noting that the game would be free to play until the closure, recent purchases would be refunded, and that a Frequently Asked Questions site had been established with more information. It ended by stating, "You have been more than a customer to us; *Faunasphere* is a family. We are so grateful for the time we had to help build a world with you." The e-mail went on to explain where to go for more information, and it thanked players for making the game "the rare, beautiful experience it has been." The letter was signed "The *Faunasphere* Team." Simultaneous notices went up on the game's login site, and the game's moderators and community managers posted similar notices to the forums.

Predictably, players were shocked, upset, and outraged. The e-mail was certainly a surprise, both to the community and to ourselves, and many players immediately gathered on the forums to discuss the news. Some did not accept that Big Fish Games (BFG) had done all that was possible to keep *Faunasphere* going, demanding to know why BFG did not turn

to the player community for financial help. One poster expressed her dismay, stating, "I have cried real tears over the news. I've never experienced a game like this before." Other players expressed how much the player community meant to them, with Mary writing that "this is where I met all my best friends. And I've had the greatest journey here. *Faunasphere* changed my life. Literally." Others expressed anger and outrage, such as Katherine, who wrote, "WHAT?!?!? ARE YOU KIDDING ME?!!! 'Phased out' to NOTHING? NOTHING AT ALL?? I'm SHOCKED, SADDENED AND PISSED OFF. I can't tell you how much in disbelief this leaves me."

Many players expressed particular anger over March 15 being chosen as the closure date, likening it to the "Ides of March" and the betrayal of Caesar. Others made references to feeling "gutted" by the news—an allusion to players' nickname for Big Fish Games's forums, "The Pond," and the use of fish avatars by players for forum posts. Overall, the great majority of players felt hurt and upset, and many demanded more information from the company, particularly a more detailed explanation for why the game was considered "unsustainable." Yet over the following days, more detailed answers were not provided, leaving players to instead speculate about why the game was being shut down. These emotional responses demonstrate how meaningful *Faunasphere* had been for these players. We discuss one potential reason for this attachment in chapter 5, but we want to note here that such emotional reactions demonstrate the value of looking beyond traditional MMOG settings and game designs, both for developers looking for a new market and for scholars looking to understand how players beyond the usual demographics relate to their games of choice.

Such player reactions are in line with the little empirical evidence we have concerning players of virtual worlds that have closed. Only a few game studies scholars have investigated such closures, with the focal point of analysis usually centering on what happens afterward, rather than before and during the sunset event. Papargyris and Poulymenakou studied the players of the science fiction themed MMOG *Earth & Beyond,* which included an account of the end of that world and how some players negotiated the closure and a subsequent migration to a new virtual world space.[1] Just as we witnessed with *Faunasphere* players, they found that at first, players expressed great anger and sadness over the closure of *Earth & Beyond*. Similarly, they also documented various players' attempts to negotiate with the game's creators to keep it open via paying higher subscription fees. The *Faunasphere* players we observed on forums and talked with via interviews similarly suggested alternative fiscal solutions to keep the game open, and many even offered the same solution—higher

subscription fees. Many others were unsure the game was actually losing money, often citing their own spending habits as evidence to the contrary. As Rebecca related on the forums just after the closure announcement, "I would gladly have paid three times as much per month to save this game from destruction. I know I've been spending at least that much, probably more each month. I really find it unimaginable that no other company would buy this money-making machine. . . . I know they said they tried all avenues, but boy, some companies are really missing out on a golden opportunity, I would think. Sigh." Similarly, Tim wrote, "Why didn't you come to all of us—the paying members—to see if we would have bought the game!" Most of those posting in the forums and responding via our interviews displayed a lack of knowledge of how game developers and publishers strategize their business—in particular, how online games such as MMOGs and social games are monetized. Many believed that because they personally were spending a lot of money on the game, *Faunasphere* must have been profitable. However, Big Fish never released any information regarding *Faunasphere*'s actual financial status. Others were upset that they had paid money for something that was now being taken away. Susan wrote, "I am furious! I have spent so much money on this game! Will be looking into whether this is legal or not!" Presumably many players had not spent money on virtual goods before, and so their ephemeral nature was unapparent.

Despite the lack of information given to them—Big Fish only said the game was unsustainable, which most players refused to believe—some players attempted to figure out why this was happening, with some claiming that Big Fish was simply inept. Allison cited the lack of advertising for the game as evidence for its demise, wondering how invested Big Fish was in *Faunasphere*'s continued success. Similarly, Hannah saw the game as ineffectually managed and with no clear idea of its target audience: "BFG NEVER understood their market ~ older women, they pandered to children and mollycoddled free players. They chastised the people who spent very large sums of money on the game (in some cases more than $1,000 US, pcm). Hopeless, ineffectual management." We were unable to ascertain what events Hannah was referring to here, but many players felt that *Faunasphere* could continue if Big Fish was a smarter and more effective company.

Big Fish's explanation for why *Faunasphere* was being "phased out" was unsatisfactory for many players, who regularly posted demands for more information over the following days. However, the continued silence on the part of Big Fish executives infuriated many players as much as the closure itself, as this response from Candace shows:

The closing of *Faunasphere* without even a single word from Paul
Thelen or any CEO from Big Fish Games. This was completely unpro-
fessional, unconscionable, despicable, and disgraceful. Delegating the
moderators of *Faunasphere* to inform us of its closing was the epitome
of cowardice and TOTAL lack of good public relations. Perseverance
in asking for a more official explanation from Thelen or a CEO was
continually ignored and our pleas fell on deaf ears. It would appear
that they were unwilling, incapable or simply refused to address this
to their faithful customers. If incapability was the issue, then I wonder
exactly how the "powers that be" can run a company, if at all.

Other players went further, directing personal insults at Thelen in particu-
lar, such as Becca, who wrote, "I have totally quit Big Fish as a member
in protest and they can rot from the head down for all I care. I am friends
on FB with most of the Moderators and it nearly killed them too. I do
not believe the 'party line' one bit about closing it down . . . but I cer-
tainly do not hold the employees accountable for it. It had to be that pig
Thelen . . . I defriended him and all the BFG sites." Not only do these
responses further show how meaningful *Faunasphere* was to its players,
they also highlight the shifting relationship between consumers and pro-
ducers brought about by the digital age.[2] These responders knew the name
of Big Fish Game's CEO and directed their anger and frustration at him
personally, and they were able to do so in a very public way. It seems likely
that the insistence on hearing from Thelen was based partially on the fact
that for him to address the community would have been as easy as writ-
ing a short paragraph on the forum. Although we can only speculate as
to why Thelen or other Big Fish management did not respond to the com-
munity, as they had posted to the forums in the past about the game and
other matters, this clearly became a public relations problem that could
have been mitigated had Big Fish provided a more detailed explanation.
Many players vowed to cancel their Big Fish accounts and boycott the
company, though just how many did, we cannot say.

Although many players were clearly deeply upset at the news, many
continued to play *Faunasphere*. Some players reported playing even more
so than they had in the past, while others reduced their playing or stopped
altogether. These activities characterize the next stage, Preclosure Activities.

Stage Two: Preclosure Activities

Many players told us that as the final month went on, they increased
their playtime in *Faunasphere*, for a variety of reasons. For some, it was

sentimental: Many players wanted to spend time visiting their various spheres and the different zones or to finish goals and projects. Some responders indicated their desire for a sense of closure in some way: This often involved completing goals or getting one or more of their fauna to level twenty—the maximum level—and thus obtaining a golden collar for it. For example, Amber explained that during the last month, she "got 5 more fauna to level 20," which would have taken considerable effort. For Amber, leveling fauna must not have been a priority before the closure announcement. Similarly, Rebecca related that she "played a LOT, even more than usual, including staying up all night the night before the game shut down to finish things up. I finished decorating several spheres (my main priority) and levelling up as many fauna to level 20 as I possibly could. . . . I also took screenshots of every sphere I created and of my final 'flock' of fauna." Katrina reported that "I spent the normal amount of time after work, but in the last week, I have to admit, I scrimped on the whole sleeping thing in favour of additional FS time. Probably 2–3 hours after work additional." Despite the game's impending closure, it was important for these players to finish what they could and to play while it was still possible.

For some players, the closure meant more than simply increasing play-time—it changed the way they played the game. Beatrice explained that "instead of just exploring and decorating and chatting I spent my time zapping to level those Fauna. I got the fourth gold collar March 14. Those four level 20 Fauna were the only ones I took to that level in two years." Beatrice's shifting habits are similar to our observation of Amber's playing.

Yet for other players, the announcement had the opposite effect: They either stopped playing entirely or greatly reduced their time doing so. After the announcement, Becca told us, "I couldn't play. I cried all the time I was on so I quit," while Hannah recalled that "I had hardly played at all since the closure announcement." Belle reacted even more strongly: "I played very little after the announcement because I was so upset and felt betrayed." Jackie said that immediately after the announcement, she was "grieving" and did not play for two weeks, before returning for the final two. Jolene went through a similar process: "In the first week after the closing announcement, I was too upset to play. Every time I would try to open the game, I'd start to cry, and so I'd close it again. After that, I was able to play a little, but not nearly as much as I had been." While some players wanted to experience as much of *Faunasphere* as they could while it still existed, these players were unable to face the impending loss.

Whether increasing or decreasing playtime, the closure announcement changed the play habits of many players. Such reports suggest that

although players may pursue activities of interest to them in online games and virtual worlds, and those interests may differ between players, scholars need to also take into account the state of the virtual world being studied. Just as the opening of the game postbeta and the launch on Facebook changed how players related to the game, so too did the closure announcement. While most of the virtual worlds researchers investigate are fairly stable, our findings show how the imminent closure changed how players approached the game—altering their frequency of play and play styles, sometimes in very dramatic ways. A player previously interested in exploring and building a world may turn to the pursuit of achievements, for example, if he or she feels that time in the world is limited—or vice versa. This could also occur if a player feels his or her own time in a game is limited (if he or she feels the need to quit soon or believes the game will be ending soon without any actual evidence). Thus when analyzing why and how a player engages with an MMOG, it is critical to take into account the state of the game world in question and players' feelings about it. For example, in our first survey, we asked players about their future plans for playing *Faunasphere*. This question would have garnered much different responses if the closure had been announced when we asked it.

Stage Three: Sunset

Most of what we know about MMOG and virtual world sunset events has come from games journalism rather than scholarly studies. Some MMOG sunsets have attempted to play into the fiction of the game. For example, *The Matrix Online* planned to have all player characters online in the world physically crushed at the final moment, although server lag precluded much impact to the dramatic event. Likewise, *Tabula Rasa,* which released a new patch two weeks before the game's closure in 2009, did so with the announcement that a final massive "Bane Assault" would mark the end of the world. Yet most MMOGs have no final plans for their world endings, as they are designed around a model that encourages (and demands) endless play and a world premised on persistence, rather than an abrupt interruption or dramatic conclusion. One notable exception would be *A Tale in the Desert,* which runs "Tellings" of the game world that last for approximately eighteen months each. Each Telling is a discrete period of time, and when a Telling concludes, achievements are tabulated, player feedback on game systems are taken into account, and a new Telling begins.

One detailed account of such closing events is Pearce's study of players of *Uru* and their subsequent travels from that space to *There.com* and

Second Life.³ Pearce argues that such closures are critical events that can tell us much about how individuals play in virtual spaces and the importance of the structures of virtual worlds in shaping that play. In particular, Pearce demonstrates how denizens of *Uru* wanted to find a space similar to their originating world yet, being unable to find something perfectly parallel, adapted their identities and activity online as they slowly migrated to other worlds:

> On the last day of *Uru*, many players assembled in-world, gathering in hoods, or visiting each other's Ages. Owing to varied time zones, not all players were able to be online at the strike of midnight [EST], the scheduled shutdown time. A core group of TGU members gathered in the garden of Lynn's Eder Kemo Age, talked, told each other stories, and played hide-and-seek. As the time approached, they moved into a circular configuration close enough so that their avatars would appear to be holding hands. Several players recall the clocks in their "rl" (real-life) homes striking midnight, the screen freezing, and a system alert message appearing on the screen: "There is something wrong with your Internet connection," followed by a dialogue box saying "OK." As one player recalled: "I couldn't bring myself to press that OK button because for me it was NOT OK."⁴

Given this account, we expected to find that players of *Faunasphere* would place a premium on being together in the space, and they would also treat it as a highly emotional experience, with both positive and negative expressions of emotion arising during the event. What we found both confirmed and challenged those expectations.

We logged on to *Faunasphere* approximately one hour before the close was scheduled, with the aim of observing the players and recording the event with a screen-capture program. During this time, we encountered various players traveling through the world, many taking final screenshots and revisiting favorite locations. One described the activity as being a "memory walk." In our later interviews, many players described their final actions as akin to what Jackie called "closing a summer home"—preparing things for a long-term closure, a shuttering of a structure, or the acknowledgment of a seasonal ending. However, we were surprised by just how few players we encountered. This was likely due in part to the time: 1:00 p.m. Eastern Standard Time on a Tuesday, but since the game could be played via web browser, we anticipated more players.

Although a few individuals later told us they could not be in *Faunasphere* for the closing because of work or other obligations, many people

we talked with cleared schedules or otherwise prepared for that final day. For example, Amber reported taking the day off from work so she could be there for the closing. Candace recounts her unfortunate experience: "I stayed up for two days and just hours before the close, I fell asleep. I so wanted to be there and let all my fauna run in their spheres. I wanted to feed them and say good bye to all of them." Lucy "booked the day off work and played almost 24 hours straight." Rachel was also there: "I was there for the closing, even requested the day off work. I denned and fed all my fauna. I then took my hoofer from beta out and about in the worlds." Although we did not observe very many players, many reported being present, a discrepancy we discuss later. Other players, such as Katrina, had to find closure beforehand: "I wasn't there for the closing. I had to work. So I did what I could do Monday night, and then signed out for the last time. I've got to say, it was really sad. We all had a very big emotional investment in FS and it was a hard thing to have that yanked away." While Rebecca was also unable to be there for the closing, she reported "staying up all night the night before the game shut down to finish things up." Thus playing with an eye toward closure and completion was a common theme among our respondents, which reinforces the point that motivation for play in an online world is heavily shaped by the state of that world.

Several players admitted to also preparing their fauna for their own impending absence, while acknowledging the (supposed) silliness of the activity. As noted before, Rachel reported feeding and walking her hoofer (horse). Amber described her final moments of play: "[I] made sure that each and every fauna was happy and had plenty of food and I cried, which is exactly what I am doing right now, lol after all they are just pixels, but i can't stop crying. . . . I took the day off work, I went to all the different worlds and said goodbye to people as we passed. During the last 5 min. I started throwing all my food from inventory on the ground (did not want anyone to starve) lol and I cried." Allison recounts a similar experience on the day of the close: "I spent the morning taking each of my 9 fauna out alongside my daughters fauna at the same time (this was a little hard for me to do alone) to make sure they all got a chance to get out, and I spent a little time with each of them. I had them all do their tricks for me and fed them well and made them as happy as I could." At the end, Rebecca treated her fauna in a similar fashion: "Right before I left I 'unhid' all my fauna (I kept most hidden in sphere to cut down on lag) so they could frolic." "Hiding" fauna effectively made them invisible in one's sphere in order to improve game performance, but Rebecca speaks of hiding as though it were akin to kenneling a pet dog or cat.

Finally, as 1:00 p.m. drew near, player activity diverged. Some individuals made their way to public spaces, gathering with friends and other players to be together, set off fireworks, say good-bye, and wait through the final moments (Figure 7).

Alternately, other players instead chose to return to their private spheres, in order to be with their fauna rather than with other players. For example, Caroline reported, "I went to the Rock Garden and said good-bye to some friends there, and then went back to my sphere to be with my babies." Beatrice also chose to spend the final moments with her fauna: "I was there until the bitter end. I felt crushed and devastated. I wanted to be with many of my friends in the Rock garden but my heart fell when I left my sphere so I spent the last hour with my Fauna, watching them play and feeding and denning them and saying 'goodbye.' Yes, I know they weren't real living animals but to me they were the joy of my life." Allison also faced the choice of whether to be with other people or her fauna while the game ended: "I went out into the rock garden and looked around for a hatless fauna. I wanted to give a hat to a caretaker that had never owned a hat before so they could have a little joy before the game ended. No luck except someone that wanted my hat anyway but was already wearing one then tried to hide it from me. I did find someone in Mire Knoll. Then I visited a few different world gates and went to my sphere ready to face facts

FIGURE 7. Players gather with their fauna in a public place as the countdown begins.

and say goodbye. I laid out more goodies for my fauna." This phenom-
enon is a possible explanation for the discrepancy we observed before: It
seems that many players were in *Faunasphere* for the close, but by staying
in their own spheres with their fauna, they were effectively invisible to us.
We explore the reasons for this behavior more fully in chapter 5.

As the time ticked down closer to the end, players still in the Rock
Garden became more active, shouting thanks and messages of affection
to fellow players as well as game moderators, several of which were pres-
ent. More and more fireworks went off, fauna did tricks for the assembled
crowd, and caretakers increasingly changed the fauna they were "using"
in the space, bringing out either old favorites or rare breeds. Yet the game
did not end at 1:00 p.m. as scheduled, instead continuing on for another
eleven minutes. At first, players said nothing, and they then began to hope
that perhaps this was a reprieve, that Big Fish had changed their minds,
or that they were to have more time in their beloved world. But then the
network connection error message appeared (Figure 8).

Ultimately there was no diegetic reason offered for the world's end, just
a cold generic error message not unlike what the denizens of *Uru* expe-
rienced.[5] Perhaps this was because the fiction of *Faunasphere* was never
premised on any sort of larger narrative or setting. After the world's clo-
sure, however, attempts to access *Faunasphere* (as well as all its official
forum pages) were rebuffed (Figure 9).

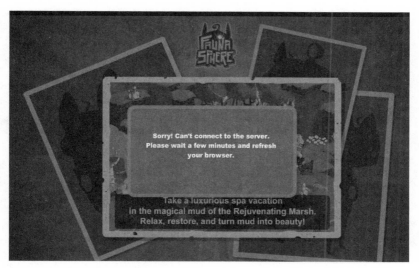

Figure 8. The ending of the game.

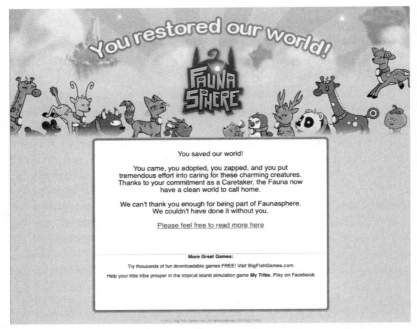

FIGURE 9. All *Faunasphere*-related websites, including the game and forums, were replaced with this message for several months. These sites now redirect to the Big Fish Games home page.

The message starts by invoking the fiction of the world: "You saved our world! You came, you adopted, you zapped, and you put tremendous effort into caring for these charming creatures. Thanks to your commitment as a Caretaker, the Fauna now have a clean world to call home." This is an allusion to the ubiquitous pollution, which has now apparently been permanently removed from the world of the fauna. Yet the pollution trope was not prominent in the game as a fictional element driving the story, instead being only briefly mentioned during the tutorial. Pollution continuously respawned and was primarily used to gain experience for fauna, and there were few long-term goals or tasks regarding pollution. As such, the idea that the world is now "clean" is somewhat strange, but it does offer a (flimsy) diegetic reason for the game's end. At the time of this writing, even this closing message has been removed, and attempts to access any *Faunasphere*-related site or the official forums now simply redirect to the Big Fish Games home page. *Faunasphere* has not just ended; it has been erased.

Overall, the final sunset was a somewhat disconnected and confusing event to observe. We had expected to see large groups gather in the game's public spaces, yet many players did not attend such gatherings, or if they did so, they only attended briefly before returning to their home spheres to "be with" their own fauna. If so many players had espoused the social nature of this space and the importance of the friendships they had made there, why would they sequester themselves at perhaps the most dramatic moment of the game's lifespan?

Such activities raise important questions about how players relate to virtual worlds and online games, as well as how game structures contribute to those practices. For many players, although friends and community were important parts of *Faunasphere* (and those parts could potentially continue through to other games and online spaces), a key component was the game itself—and specifically the fauna they had bred and raised. For these players, being with their fauna at the end—spending time with virtual creatures—was more important at that moment than being with human friends. In a sense, the fauna had become their friends, their family. While other friends might later be contacted on a Facebook group, the fauna could not. Thus it was important to players to spend those last few minutes with their virtual creations.

Stage Four: Decline

A unifying thread cutting across all discussions of MMOG closures has been evidence that players do not simply disperse and stop playing—instead, many actively work to form groups and relocate their play activities elsewhere, often investing great energy in the search for a new virtual "home."[6] Their activities point to a determination to keep playing together in some manner and to do so in places that match their interests and/or values, as well as to keep playing with a select group of friends or family.

Immediately after the shutdown, many *Faunasphere* players gathered in places such as the Faunasphere Memories group on Facebook and the Faunasphere Orphans forum, where they posted screenshots of their fauna and the sunset event and commented extensively on one another's responses. While initial reactions were of great sadness as well as anger, most (but not all) group members eventually became less emotional and used these spaces for sharing remembrances and discussing other games that might be worth attempting. One interesting feature to emerge was artwork created by the members, including mash-up screenshots (which featured different fauna grouped together or in comic form, or perhaps a player's fauna along with his or her new *Glitch* avatar), videos, and

other memorabilia. There was general discussion of the high points of the game and calls for more contact between ex-players. Likewise, there were proposals for a petition to present to Big Fish demanding the game be reopened, the circulation of an open letter to Paul Thelen demanding more information about the closure, as well as strongly expressed senti- ments about Big Fish and many statements from individuals stating they would be boycotting all future Big Fish products.

Eventually, splinter groups formed, as for example some ex-*Faunasphere* residents were admitted into the alpha test for *Glitch* and began enthu- siastically discussing that game. "Glitchers" set up their own separate Facebook group to discuss the game, yet many still participated on the original Faunasphere Memories group space as well. They also created an identity for themselves within *Glitch* as "FS Refugees" with a forum and in-game chat channel in order to more easily find one another and share new and older experiences. This activity echoes Pearce's findings regarding how former *Uru* players searched for a new online home while referring to themselves as refugees.[7] The former *Faunasphere* players also took pains to either name themselves with their *Faunasphere* name or make lists and announcements of players' "real" *Faunasphere* and *Glitch* names so that fellow ex-*Faunasphere* players could find them.

While the Faunasphere Orphans forum has since closed, the Facebook group remained remarkably active in June 2013, twenty-seven months past the closure of *Faunasphere*.[8] Players continue to post screenshots and videos of their fauna and spheres, as well as chat and share information about their fellow players. While volume has decreased, much of the spirit of the original group remains, and members obviously see themselves as part of a continuing community. Many players continue to post messages expressing their sadness over the loss of *Faunasphere* and their hopes that Big Fish will see fit to reopen their lost home. It is ironic that Facebook, so frequently cited as the source of the game's decline, is now keeping the community together.

Implications for MMOG Research

The former players of *Faunasphere* have continuously challenged what we usually take for granted about online gameplay, particularly in the MMOG space and its related theorization. For example, much player- based research (including our initial work on this topic) has been concerned with understanding the play styles of players and their inter- ests and motivations for play.[9] Such work has led to the creation of more

or less rigid taxonomies of "player types" such as Bartle's famous model. Writing more recently in relation to social games, Bartle reiterates the stability of his model for virtual worlds, arguing that "not only can players be associated with particular types, but their relationships with players of other (or the same) types can be ascertained and the consequences played out."[10]

Yet the activities of *Faunasphere* players during the month before sunset question the stability of that model. Although we did not categorize them as "achievers," "socializers," or such, we found that some players recognizably changed roles in those final days. For example, Beatrice, who normally was not interested in leveling fauna, stated that she had "made a promise" to several of her fauna to get them to the maximum level, in order for them to attain gold collars. She thus began "grinding" in a sense, in order to achieve a goal she otherwise would not likely have set. So some players who might have enjoyed socializing and exploring during the game's regular period became dedicated "achievers" who saw their primary goal as leveling their fauna up and so began grinding to meet that challenge. Thus players proved willing and able to radically change their play styles. While this activity does not add new categories of player types to Bartle's model, it does suggest that players may themselves be more fluid in their activities and interests than the model suggests.

Some would argue that such changes were likely due to the impending closure, but it is worth investigating in other contexts and in other games just how stable types can be. Bartle believes that the model "purports to identify four different *types* of people who play virtual worlds,"[11] but perhaps these are better thought of as play styles or roles that different players move in and through, depending on their interests, play context, and the state of the game world itself.

We can say the same for research differentiating between heavy and more casual players and their play frequencies. We heard from players who drastically increased their playtime to finish goals or spend more time socializing with others (with such heavy play periods, they may have qualified as addicted in another study) and other players who did the opposite—either quitting completely upon hearing the initial news or cutting their playtime down to almost nothing due to their uncontrolled emotions (both grief and anger) about the impending end. Although players may have certain norms for play during particular periods, those norms can be cast aside and play dramatically increased or decreased depending on the changing context as well as the players' own reactions to those contexts.

Thus game studies scholars would be better served by asking not only if players change their play frequency over the life of a game (and over their own play history) but also if the *way they play* and their *reasons for playing* themselves change. Obviously in this case, we saw evidence that they did. This further suggests that play styles, interests, and frequencies may be much more fluid and context dependent than most research allows for. Perhaps it was the extraordinary event of the sunset that drove such changes. Yet in other games, there are often rumors of shutdowns, server mergers, and generally diminishing support for the space. This too must play a role in how players choose to invest their time (or not) in virtual worlds. We need better, more refined studies of the life courses of players to more adequately capture this activity. In chapter 1 we argued that the fiction of an MMOG should be considered when analyzing player activity, as it provides a meaningful context to those actions. For example, achievement in a game like *Faunasphere* may be very different from achievement in an MMOG such as *World of Warcraft*. As we have shown here, the current state of the world plays a role as well and needs to be considered when analyzing player behavior.

This line of research also calls for studies of other online worlds as they are in the process of closing. While the four-stage process we have outlined in this chapter described the closing of *Faunasphere*, similar studies of closing worlds are necessary to determine if this process is universal or was particular to this exceptionally nonviolent, unusual game. As more MMOGs are opened and closed, there will be great opportunity to further our understanding of how and why players engage with these games in the ways that they do.

"Why Am I So Heartbroken?"

Exploring the Bonds
between Players and Fauna

Faunasphere was more than a game, it was stress relief, it made me happy when I was sad. The fauna were like pets that needed you to care for them.

—AMBER

We know that individuals in many massively multiplayer online games (MMOGs) and virtual worlds develop attachments to the spaces and people they spend so much time with, but players of *Faunasphere* present a different way of understanding online gameplay—one that challenges dominant theorization about such spaces. In part that's due to the particular fiction and gameplay design of *Faunasphere*, which addressed players not as avatars within a space but as caretakers of many fauna that could be raised and cared for across different spaces. That shift led to differences in how players saw their role in the game and also created a different kind of attachment to the game space: one based on relationships to virtual pets rather than to humanoid avatars or player-characters.

Because of those differences, fauna filled a variety of roles for *Faunasphere* players. Fictionally, they were pets to be cared for by the players, but they also functioned as mediators of a player's agency, suggesting that fauna could be framed as avatars or player-characters. However, there is not a sound consensus among game scholars as to how these two concepts differ: Some theorists posit a concrete distinction between avatars and player-characters,[1] whereas many others simply use *avatar* as a catch-all term.[2]

In this chapter, we show how fauna don't fall cleanly into either category and therefore make us reconsider current theories of avatars and

player-characters. We also examine in what ways fauna could be considered virtual pets akin to *Tamagotchi* and argue that fauna were a combination of all three phenomena. In so doing, we argue for the value of studies that consider individual games from a detailed, phenomenological perspective that in turn show the difficulties in theorizing games generally or even across genres.

Fauna as Virtual Pets

Like Amber, many other players explained to us how extremely attached to their fauna they were. And due to those strong bonds, many players chose to spend their final in-game moments with their fauna, rather than with other players who they likely considered friends. In our postclosure questionnaire, many respondents elaborated on that event, describing a deep sadness over the loss of their fauna. Players who responded often compared their fauna to pets or even their own children. For example, in response to our question, "What will you miss most about *Faunasphere*?" Becca wrote, "Don't make me cry. My beloved fauna," while Patty answered, "Creating and caring for the little ones." This attitude has persisted into the Facebook group Faunasphere Memories, where many members have expressed similar feelings. Donna posted, "I'm missing it so much, just a big void. I have empty nest syndrome my fauna were my babies. It's heart breaking. Missing F/S and all the fun we had. Just too sad for words."

Players who talked with us about their experiences frequently either referred to fauna as pets directly or drew an analogy between the two. For example, Beatrice told us, "I have no family and no pets. *Faunasphere* helped fill those painful gaps in my life." Fauna played a similar role for Denise: "Fauna became like pets, since I can't have one in my apartment because the fees are too much to pay." Even players who had real-life pets, such as Candace, saw fauna in this way: "My fauna were my favourite part. I cared for them as I care for my real life pets." For some of our respondents, the game's closing highlighted the nature of the caretaker–fauna relationship and emphasized its owner–pet qualities. Paula wrote, "We have lost a community, the equivalent of beloved pets and a connection to others." For Patty, the closing was almost traumatic: "It was heartbreaking, sort of like when you have to put a pet to sleep." Last, Jolene vividly connects fauna to pets to make a moral argument: "If you look at the premise of the game, it's about naming and raising pets. In the real world, a good person would never just walk away and abandon their pet, and that's what BFG [Big Fish Games] made us do."

Recall from chapter 1 that our initial survey reported that for most play-
ers, "Completing Goals" was the game's most enjoyable activity, beating
out "Leveling Fauna" and "Breeding Fauna." This suggests that some play-
ers might disagree that the game's main premise was "naming and raising
pets," but for many of these players, fauna approached the status of pets.
Given the strength of player reactions to the loss of their fauna, and the
number of those who spoke of fauna as their pets, understanding the pet-
like aspects of fauna becomes essential. To help us do that, we first draw a
parallel between fauna and another popular virtual pet, *Tamagotchi*.[3]

The first *Tamagotchi* was released in the United States in 1997. It took
the form of a small, plastic, egg-like keychain with a simple LCD screen
and three small buttons, and it had one function: the running of a simple
virtual pet program. Users would feed, clean, and take care of these vir-
tual pets, known collectively as *Tamagotchi*, although there were actually
several named types of *Tamagotchi* (the word *Tamagotchi* can refer to the
virtual creature or the entire physical device). Several authors, such as Alli-
son,[4] Bloch and Lemish,[5] and Turkle,[6] refer to these activities collectively as
"caretaking," which has obvious resonance with *Faunasphere*. *Tamagotchi*
were notable in that they could not be turned off and so required constant
attention. They would eventually "die," often due to the user losing inter-
est. Visually the *Tamagotchi* appeared as simple imaginary creatures. Unlike
fauna, they were not designed to resemble real creatures, a fact that—
combined with the nature of the screen, which could only render individual
pixels as on or off—resulted in very simple images, as shown in Figure 10.

FIGURE 10. An early-stage *Tamagotchi*. Image copyright
2005 by Tomasz Sienicki.

Many studies of *Tamagotchi* have remarked on how attached users, particularly children, became to them. This attachment is often framed in terms of an owner–pet relationship:

> One of the most noted characteristics of the *Tamagotchi*, however, and one that contributes to its popular and global appeal, is the uncanny sense of presence it generates in players. Owners repeatedly comment on how their *Tamagotchi* feel "real," and how they interact with these pixelated images as if they were "actual pets," [. . .] By manipulating buttons on the toy and icons on the screen, a player attends to her *Tamagotchi's* needs and desires (for food, play, discipline, medicine, attention, and poop cleanup).[7]

Tamagotchi inevitably die, and a variety of mourning rituals have been observed: "Users across the world have 'played' with this loss in a variety of ways. There has been a host of virtual memorials—obituaries, graveyards, funerals, and testimonials—printed mainly on the web but even in obituaries published in regular newspapers."[8] Turkle recounts several obituaries left by *Tamagotchi* owners at such a site, which she argues is notable especially given that the *Tamagotchi* device could be reset, allowing the user to start over after a previous *Tamagotchi* had died. This does not seem to have mitigated the sense of loss, as Turkle further observed, "Children . . . dread the demise and rebirth of *Tamagotchis*. These provoke genuine remorse because, as one nine-year-old puts it, 'It didn't have to happen. I could have taken better care.'"[9] She also recounts several stories of children who refused to reset a *Tamagotchi* and insisted on being given a new one instead.[10] These feelings are clearly similar to those expressed by players regarding the loss of their fauna in our postclosure survey responses.

Some *Faunasphere* players such as Jackie tried to comfort other upset players by appealing to the rules of the game, demonstrating that they could overcome their inability to continue caring for their fauna: "Don't worry . . . a lot of us laid out food, water and toys in our spheres. [We know] the gate system will allow them to travel between spheres and of course our babies share . . . so don't worry! Your babies are fine! :).". Jackie's post shows how far some players anthropomorphized their fauna: There was no way in the game to provide toys or water for fauna. Puzzles expressed similar sentiments: "I finished getting my photos yesterday, and left my babies for the last time. I can't be there to see the end. I have to think of them playing forever not a dead server." These reactions, and countless similar expressions in the Faunasphere Memories group, show that many players had a strong emotional attachment to their fauna, much more so than we expected. How did this occur?

Both Allison and Turkle locate players' sense of attachment to, and mourning of, their *Tamagotchi* in the nature of the relationship. Allison writes, "The mode of interactivity mimics that of raising a flesh-and-blood pet: an imaginary construction that makes players feel not only *as if* their *Tamagotchi* were alive but also that their caregiving has life-and-death implications."[11] She continues, "Relating to the *Tamagotchi* *as if* it were alive produces a bond that is deeply personal, intimate, and social."[12] For Allison, this "mode of interactivity" lead to users forming an unusually strong attachment to their *Tamagotchi,* but she also highlights the nonviolent nature of the game: "The care taken by children in raising their digital pets encouraged a degree of personalization and emotional closeness with cybertechnology previously unseen with kids. Here the mode of operation is nurturance, in contrast to the more competitive stance demanded by fighting and action that is the prevailing motif in the bulk of videogames even today. This focus draws in more girls to an electronic game field still dominated (in the United States, at least) by males."[13] The fact that *Tamagotchi* depend on their owner to care for them seems to be the source of this "emotional closeness." Turkle would agree: "Where is digital fancy bred? Most of all, in the demand for care. Nurturance is the 'killer app.'"[14] Bloch and Lemish also highlight this aspect of *Tamagotchi:* "The very nature of playing here takes place within the meta-narrative of the nurturing theme, rather than within the framework of a competitive game of destruction or conquest."[15] For Allison, the fact that interaction with the *Tamagotchi* was defined by nurturing, not violence, explains the product's particular success with girls. As discussed in more detail previously, *Faunasphere* players were predominantly women. While we did not ask them about the nonviolent nature of the game in either survey, some cited this aspect as part of *Faunasphere*'s appeal. Patty told us that she did try playing other MMOGs besides *Faunasphere* but did not stick with any of them because she does not like "battling." Rebecca told us of a game she was interested in trying post-*Faunasphere*, but she was pessimistic because "it looks to be too much battling to me." In drawing this parallel, we are not arguing that caring and nonviolence are prerequisites for women to enjoy videogames but instead showing how nurturing and caretaking lead to emotional attachment.

One major difference between *Tamagotchi* and fauna was vulnerability. Left insufficiently cared for, a *Tamagotchi* would perish, which Allison notes was inevitable: "Eventually, however, players will ignore their *Tamagotchi* long enough that they die."[16] Fauna, on the other hand, were essentially immortal. They required no regular upkeep, food, or cleaning, and so waning interest in *Faunasphere* did not have any impact on fauna.

A free *Faunasphere* account could, in theory, have kept three fauna in existence indefinitely and a premium account more. For Turkle, the fact that *Tamagotchi* die leads to deeper and troubling questions about how children think about aliveness:

> In the classic children's story *The Velveteen Rabbit*, a stuffed animal becomes "real" because of a child's love. *Tamagotchis* do not wait passively but demand attention and claim that without it they will not survive. With this aggressive demand for care, the question of biological aliveness almost falls away. We love what we nurture; if a *Tamagotchi* makes you love it, and you feel it loves you in return, it is alive enough to be a creature. It is alive enough to share a bit of your life.[17]

In Turkle's view, the fact that *Tamagotchi* continually demand attention, coupled with the fact that this "attention" takes the form of caretaking and nurturance, is what creates such a powerful bond between player and virtual pet. Turkle's emphasis on how children come to perceive *Tamagotchi* as living is relevant in that it sheds some light on the question of how *Faunasphere* players came to feel so strongly about their fauna. Turkle and Allison both agree that nurturing leads to emotional attachment, an idea reinforced by our findings.

For Turkle, however, the important question is a psychological and cognitive one: She is concerned with children actually believing *Tamagotchi* to be alive. While we have no reason to believe that *Faunasphere* players actually made such cognitive leaps (especially given that most were well beyond the ages Turkle is concerned with), our survey respondents often used language suggesting as much. Amber was exceptionally aware of this contradiction: "So in this last month I got 5 more fauna to level 20, did the best i could with decorating my spheres, made sure that each and every fauna was happy and had plenty of food and I cried, which is exactly what I am doing right now, lol after all they are just pixels, but i can't stop crying. I am a grown woman after all, not a kid, so why am I so heartbroken." That Amber expects such behavior from children certainly aligns with Allison's and Turkle's findings of *Tamagotchi* players. Amber's sense that her own feelings are absurd, especially given how powerful they are, illustrates that the question of "aliveness" does not necessarily figure into a user's attachment to a virtual creature.

Although fauna and *Tamagotchi* were the subjects of powerful emotional attachments on the part of their users, they are quite different in several ways. Although *Faunasphere* referred to players as "caretakers"

and they took that role seriously, the activities that players engaged in with their fauna were much more game-like. Fauna were used to complete quests, to chat, and to explore. They could be given food to restore their energy and happiness, but this was not a matter of life and death. *Tamagotchi* were less active, although they would go through several stages of growth, turning into different kinds of creatures depending on how well or poorly they were treated; thus some forms were more desirable than others.[18] Fauna were less plastic, only going through two stages of growth—from infant to adult—and even then the difference was mainly one of size: Newborn fauna were slightly weaker in their zapping endurance than adult fauna, but once they became adults, that discrepancy disappeared. In this regard, fauna did not have much in the way of personalities in the way *Tamagotchi* did (personalities being an aspect of the forms). In light of the differences in requirements and interaction between *Tamagotchi* and fauna, the latter seems less likely a candidate for emotional attachment. Much of Allison's and Turkle's respective analyses emphasizes the *Tamagotchi*'s dependence on the user for survival as the mechanism by which users became attached, an aspect fauna lacked. However, what fauna lacked in dependence they made up for in playfulness. Their visual appearance was much more nuanced, appearing as colorful, expressive creatures in a whimsical fantasy setting. Players would experience this world through playing with their fauna, who would accompany them as they undertook quests and adventures in an almost *Calvin & Hobbes* fashion. Fauna could be played with directly by having them perform their tricks. Play itself can be a powerful agent for forming emotional attachments. Stuart Brown has shown how play can be used to create powerful bonds between different people, different animals, and across species.[19] Similarly, Mival, Cringean, and Benyon have studied the potential of using robotic pets to provide companionship to the elderly. One of their subjects was skeptical that Sony's robotic dog AIBO could provide real companionship, but when the researchers enabled him to "play" chess against the AIBO (through a complex "Wizard of Oz" scenario), he changed his mind.[20] That players encountered and interacted with fauna in a play context may have contributed to the strength of the bonds they formed, having a similar effect to the *Tamagotchi*'s dependence. Of course, all the players' actions regarding fauna were framed by the game's fiction as "caretaking," and the quotations throughout this book show that players adopted this terminology. Thus interacting with fauna was a liminal space, existing between caretaking, nurturing, and playing, all of which are aspects of raising a real pet.

Fauna as Avatars or Player-Characters?

Although it's possible to limit the discussion of the player–fauna bond to one of virtual pets and caretaking behaviors, we should acknowledge how other MMOGs have constructed the player–game relationship. Multiple theories and definitions of the avatar have been offered by games and new media scholars, but there's little consistency from one theory to the next. Instead the term has been used to refer to many different phenomena, which in turn means that different theories have different foci. In this section, we disentangle ideas of the "avatar" from those of the "player-character" and examine how these theories might apply to fauna.

With regards to avatars, some theories emphasize the role of identity, while others are more concerned with an avatar's functional aspects. Adopting Boudreau's definition, we mean *avatar* to refer to a player-created entity meant to represent a user. As such, the term refers to the characters used by players in games such as *World of Warcraft* and virtual worlds such as *Second Life*. Boudreau distinguishes *avatar* from *player-character*, which is "a pre-created, scripted character that the player controls within the structured confines of a videogame narrative. The player often has limited ability to alter the player-character beyond the basic armour, weapon, and skill upgrades that are necessary to develop in order to successfully complete the game's challenges, if at all."[21] Because they are "pre-created" and "scripted," player-characters have their own identity and role in the game's fictional world.

In some of the earliest writing on digital avatars, Janet Murray applied the term broadly and connected it to user identity: "In digital environments we can put on a mask by acting through an avatar. An avatar is a graphical figure like a character in a videogame. In many Internet games and chat rooms, participants select an avatar in order to enter the common space. Even when avatars are crudely drawn or offer a very limited choice of personalization, they can still provide alternate identities that can be energetically employed."[22] Murray's use of *avatar* is broad, ranging from technologies such as web forums and instant messaging to online games. Her phrase "crudely drawn" evokes the myriad forums and social networks where users can upload any image as a loose representation of themselves. In such cases, these avatars are linked to their user's identity in that users can identify each other in part via their respective avatars. We say "in part" because in many cases, this avatar is more fluid and subject to change than other identifiers, such as a username. This was particularly the case in *Faunasphere,* where players could change fauna at any time; only their username remained constant and as such was a stronger

marker of identity. It's also noteworthy that Murray does not distinguish *player-character* from *avatar*: She states that videogame characters are a kind of avatar.

Likewise, Celia Pearce doesn't differentiate "avatars" from "player-characters," instead arguing that over time the terms have become synonymous: "Initially, 'avatar' was used exclusively to describe players in MMOWs, but it has also been adapted to MMOGs, along with 'player character,' 'PC,' or, more recently, 'toon' (short for cartoon), used primarily in *World of Warcraft*."[23] However, Pearce's avatars align with Boudreau's definition in that Pearce focuses on their roles as customizable representations of the players using them in a networked environment.

Pearce is interested in the role of avatars in MMOGs where the social aspect is key: Her definition of *avatar* depends on a social context. Pearce writes, "Being an avatar means exploring the self as much as it means exploring others; more specifically, it means exploring the self *through* others,"[24] and she further observes that "we become emotionally attached to our projected identities."[25] For Pearce, the identity aspect of avatars is essential to understanding both how they work and how they become meaningful to players in an online game space. Indeed, Pearce found that "players form strong emotional bonds with their avatars, as do members of their social circle."[26] These claims are well supported by her data and observations, and in terms of player attachment, they resonate with our findings regarding fauna.

However, Pearce's work is based on her ethnography in the *Myst*-derived MMOG *Uru Live*, and fauna were different from the Uruvians' avatars in many ways. Fauna could act as the means for players to interact with each other, via public chat or simply playing together. But fauna were not "essential unit[s] in the play community,"[27] because a player was able to change fauna at any given moment and could "release" (i.e., delete) fauna at will. Furthermore, the player's account name, not the fauna's name, was always displayed over one's fauna. Fauna were temporary, but the player's username was not, and so this was a much stronger identifier of a player than any given fauna. Pearce observed players becoming attached to each other's avatars, which would have been less likely in *Faunasphere*. This is not to say that identifying other people on the basis of their fauna alone was impossible, as many players expressed preferences in using certain fauna over others, but rather that the link between a player and a fauna was weaker than the link between an Uruvian and his or her avatar because changing fauna was trivial and the game encouraged players to have multiple fauna rather than just one. Further, avatars

in *Uru Live* were directly created and customized by players when they first created their account, which is much different from the indirect collaboration (due to the circulation of eggs) and weighted randomness of fauna creation. Because the avatars of *Uru Live* were human, it was possible to create an avatar that looked like yourself. Pearce speaks of "being an avatar," which makes sense in *Uru* but not *Faunasphere*.

Whereas Murray's and Pearce's work on avatars focused on their role as representations of players in online environments, Rune Klevjer is concerned with single-player games, particularly those where the player navigates a character through a three-dimensional environment. Klevjer uses *avatar* and *player-character* interchangeably: "The dominant definition of the concept of the avatar in computer game discourses originates in the tradition of role-playing games, but its typical use has been expanded to include also distinctly non-configurable and ready-made playable characters like Mario and Lara Croft. More narrowly even, and further removed from my own use of the concept, 'avatar' is also sometimes used to refer to the playable character as a mediator of communication and self-expression in multi-user virtual worlds."[28] Klevjer's perspective on the two terms is the inverse of Boudreau's and ours in that he sees *avatar*, not *player-character*, as primarily describing nonconfigurable characters in single-player games. Klevjer defines *avatar* as "the embodied manifestation of the player's engagement with the gameworld; it is the player incarnated."[29] For Klevjer, playing a game through an avatar is "a form of make-believe" used by players to engage with simulated, fictional worlds.[30] Klevjer is primarily interested in single-player action-adventure games where the avatar "mediates between the player and the game"—an action distinct from the avatars of MMOGs, which have the added task of mediating between "the player and other players." For Klevjer, MMOGs are less suitable for the study of avatars because the social aspect "demands primary attention,"[31] whereas in single-player games, the emphasis is on how the player interacts with the game through the avatar.

Possibly as a result of this focus, Klevjer argues against identification: "The avatar is primarily a mediator of agency and control, not a 'character' that we identify with . . . As an embodied extension or prosthesis, the avatar is important because it enables us to act in the world of the game."[32] Klevjer's emphasis on agency and control does have some resonance with how fauna functioned: They made playing the game possible, and our survey respondents clearly did not identify with their fauna. However, Klevjer also argues that the avatar is neither "'a character on screen,' nor merely a cursor or a 'complex' of forces and influences, but

an incarnated subject-position for the player within a fictional environment."[33] The idea of the avatar as "incarnated subject position" is key to Klevjer's theory: The player acts and perceives through the avatar. Here one can see how his emphasis on single-player, three-dimensional games forms the basis of his theory. In many two-dimensional games, including *Faunasphere*, the player's perception of the environment is not contingent on the avatar. Klevjer acknowledges this fact, noting that players of *Donkey Kong* would not explain their failure to jump over an obstacle by "referring to the fact that Mario was turned the other way and could not see it coming."[34]

Another key aspect of Klevjer's theory is that avatars enable simulated physical interaction with their environment, and thus the environment becomes "tangible." This kind of interaction is direct and as such is distinguished from "indirect or informational manipulation." The latter includes "symbolic interactions" such as textual or through a mouse.[35] In *Faunasphere,* interaction was indirect and the environment was therefore less tangible. Players moved through the world of *Faunasphere* by clicking on the ground, which would then cause the fauna to move to that spot. The environment could be interacted with: For example, fauna could be directed to shake trees, but this was always through the mouse cursor first. Shaking trees also did not require any extra input on the part of the player: Once being directed to do so, the fauna would shake the tree of their own accord. In most cases, the player did not interact directly with the environment but rather "told" the fauna what to do (the exceptions being when using the marketplace and when building a sphere).

In fact, it is the use of the mouse in *Faunasphere* that prevents fauna from being avatars in Klevjer's terms: "The avatar is not a cursor or a mere instrument, but gives the player a meaningful embodied presence and agency within the screen-projected environment of the game."[36] For Klevjer, this is a difference between "real-time control—which simulates a physically tangible relationship" and "real-time interaction." Fauna were not tangible because they were controlled indirectly through the mouse cursor, even though they were still interacted with in real time. This added an extra layer to the interaction: Players used the mouse to tell fauna where to go and what to do; there was no 1:1 of input and fauna action. This was akin to the input style of *Diablo*, which Klevjer claims is "ambiguous" in that avatarial control is not tangible but the input is fast enough to approach tangibility.[37] However, interaction in *Faunasphere* was much slower and methodical than in *Diablo*, so fauna were nontangible.

Although Klevjer's theory of the avatar fits with fauna on some points, particularly the idea that players do not identify with avatars, ultimately he is describing a different phenomenon. Fauna were not tangible and consequently do not fit his definition of avatars as the "embodied manifestation" of a player's agency.[38] It is also important to note Klevjer's emphasis on the mode of interaction in defining the avatar. As described previously, the fiction of *Faunasphere* made it explicitly clear that fauna were not meant to represent the player, but for Klevjer, such a fact would not seem to matter.

Jillian Hamilton echoes some of Murray's and Pearce's ideas about the range of avatars and player-avatar identity and like Klevjer is interested in how players interact with avatars. Along with Murray, Hamilton is interested in a wide range of possible configurations of avatars, and she applies the term to everything from small images used as avatars in instant messaging programs and forum profiles to three-dimensional animated models used in networked games.[39] Hamilton links avatars to identity: "At a base level, an avatar describes the manifestation of the self in a screen-world. In this, an avatar provides an expression of identity. . . . We might think of them as providing a mechanism and context for exploring and playing out aspects of the self through an unbounded discursive process."[40] This definition of the avatar is similar to Pearce's claim that avatars allow players to explore the self.[41] Hamilton further argues that "we might identify just as strongly with an arbitrary or symbolic pixel art image in some contexts as a highly rendered, highly individuated 3D self-portrait in others. This is because it is not visual exactitude that produces identification, but capturing a likeness, essence, or even a signified."[42] This idea recalls Scott McCloud's theory that the appeal of cartoons is that abstracted characters are easier for a wider audience to identify with.[43] However, Hamilton also suggests that this identification with the avatar is furthered by the fact that "it reflects our intentionality, our agency and our social participation,"[44] an idea at once reminiscent of Klevjer's emphasis on the avatar as tangible and Pearce's emphasis on the networked play community. For Hamilton, then, *avatar* describes a wide range of phenomena, and what links them all together is that in each case, the avatar is something we identify with on the basis of function. The form of the avatar can make a difference in how easily a player identifies with it, but this is secondary to its functional elements.

Both Hamilton and Klevjer place less emphasis on the role the avatar plays in the context of the game's fiction or narrative than how it functions. Even though fauna were cartoonish and abstracted in the way

Hamilton and McCloud discuss, we have no evidence suggesting players identified with their fauna. While this may be partially due to their functional role and the nature of the game's point-and-click interaction, the game's fiction always presented fauna as pets in need of care and support, which we believe influenced how players perceived fauna and their resulting attachment to them. Thus the fictional aspect of avatars and player-characters can potentially have a stronger effect on players than their functional aspects.

Taking a different approach, Jonas Linderoth conducted a series of studies wherein children were recorded playing local multiplayer console games in their living rooms. As a result, he focuses on the context of play and the nature of the game rather than offering a general definition: "The meanings of avatars depend on how they are framed by the player, thus they can have at least three different functions. Avatars can become *roles* for socio-dramatic interaction. As extensions of the player's agency, avatars can become *tools* for handling the game state. Finally, when choosing and using avatars in the presence of others, avatars can become a part of our identity, not as alter egos but as *props* for our presentation of self on the social arena surrounding the game."[45] The games used in Linderoth's studies featured player-characters, not avatars, under Boudreau's rubric.[46] In terms of fauna, "tools" describes their functional role well, as they were primarily used to manipulate the game state. Linderoth also uses the "tools" function to explain the oft-cited phenomenon of players using the word "I" to refer to in-game actions—for example, saying "I died" or "I beat the game," not "Drake died" or "Drake beat the game." He writes, "When the avatar becomes a tool for the player, an extension of her or his agency, the term 'I' refers to the player-avatar unit. This is not a phenomenon which is unique for the gaming activity, it occurs in other cases when our ability to act in a certain activity system mediated by a tool."[47] Other cases include activities such as driving a car, where we are prone to expressions such as "he hit me" or "she cut me off." Fauna could also be seen as props, as choosing a fauna could have been an aesthetic choice and could thereby reflect the player's preferences and tastes. For example, a player may have preferred her white sniffer over her red hoofer and consequently used her sniffer more. Given the lack of customization options for fauna, the prop function is weaker than the tool function. However, neither function explains the emotional attachment players reported having to their fauna.

Reviewing theorization about avatars and player-characters illustrates at least two points. First, the theoretical landscape on avatars is weakened

by the fact that the term has been applied to myriad phenomena, result-
ing in little consistency. Second, fauna do not fit the majority of criteria
for being avatars. They were only customizable to a minor degree, they
were not directly controllable by a player, and they were not strict repre-
sentations of the players controlling them. Notably, none of these theories
of the avatar pay particular attention to what we have argued to be the
most essential characteristic of fauna: their status as separate entities in
the game's fictional world. The idea that fauna were individual creatures
that needed players to take care of them permeated the game, and this
strongly influenced how players saw themselves and their fauna. How-
ever, the prior literature that we have discussed so far doesn't distinguish
between *avatar* and *player-character*. To return to Boudreau's distinction
between the two, she notes that the latter is controlled by a player "within
the structured confines of a videogame narrative."[48] To what extent then
should fauna be considered player-characters?

Although she does not make use of the term *player-character*, Kathy
Cleland posits a spectrum of degrees of player–avatar identification: "At
one end of the spectrum, the individual may identify with her avatar
representation so closely that it is experienced as an intimate extension
of her own subjectivity and becomes an intensely felt *second self*. This
is particularly the case when the individual has invested a lot of time
and effort in designing or customizing her avatar identity and when the
avatar reflects strong aspects of the individual's own psyche or aspira-
tions." As with other theories of the avatar, fauna do not fit at this end
of the spectrum. Cleland continues, "At the other end of the spectrum
the avatar may be experienced as a totally separate other, an entity that
is clearly disconnected from the self. This is the case where there is mini-
mal personalisation of the avatar and where the individual invests little
or nothing of himself in the avatar identity."[49] This end of the spectrum
describes a phenomenon more akin to the player-character and what we
saw of fauna. Players saw their fauna as "totally separate other[s]," and
personalization of fauna was minimal. This fits Boudreau's definition of
the player-character, which emphasizes limited customization and per-
sonalization.[50] Recall that fauna were customizable in the sense that the
outcome of a hatched egg was influenced by the "parent" fauna but also
included a degree of randomness. It was also possible to earn a gold-
colored collar for a fauna by leveling it up to twenty, and later patches
added the ability to acquire hats for fauna to wear. However, both of these
items were hard to acquire, and this customization took place after the
fauna had been created. These two elements were the most direct way a

player could customize a fauna, whereas with avatars the greatest customization opportunity is typically when the avatar is created.

In *The Rules of Play*, Katie Salen and Eric Zimmerman do not make a sharp distinction between avatars and player-characters, but they adopt the latter term and limit the bulk of their discussion to single-player narrative-driven games. For Salen and Zimmerman, the idea that players identify with their avatars or player-characters is tied to the "immersive fallacy," which is "the idea that the pleasure of a media experience lies in its ability to sensually transport the participant into an illusory, simulated reality."[51] They continue, "The immersive fallacy would assert that a player has an 'immersive' relationship with the character, that to play the character is to *become* the character. In the immersive fallacy's ideal game, the player would identify completely with the character, the game's frame would drop away, and the player would lose him or herself totally within the game character."[52] While this kind of avatar- and player-character-identification rhetoric is common in theories of the avatar, Salen and Zimmerman are clearly skeptical that such identification takes place or that it would even be desirable from a game design standpoint. Instead, they point to Fine's[53] study of players of pen-and-paper RPGs, which highlights the fact that the relationship between a player and a player-character is not one of simple identification: "This three-fold framing of player consciousness—as a *character* in a simulated world, as a *player* in a game, and as a *person* in a larger social setting—elegantly sketches out the experience of play. . . . Fine makes the important point that movement among these frames is fluid and constant, and that it is possible to switch between them several times in the course of a single verbal statement or game action."[54] This model, and its emphasis on fluidity, does describe *Faunasphere* to an extent in that players showed little trouble navigating between these different frames. However, how the role of "character" would apply to *Faunasphere* is somewhat nebulous: Are the fauna characters, or are the caretakers the characters? It would make sense to classify *both* roles as characters, a phenomenon not addressed by many theories of avatars and player-characters.

One scholar who has considered the "many character" problem is Darryl Woodford, who has called for a distinction between avatars and player-characters: "In games like *Tomb Raider*, the player takes on the role of an agent whose characteristics, back story, morals and other facets of their personality are scripted by somebody else, often the game designer, but also potentially, authors or directors who published books or established movie franchises. This is far from the early idea where the

avatar was a representation of the player, moulded in their image and sub-servient to their wishes and desires."[55] For Woodford, a key distinction between avatars and player-characters is the nature of their creation. The former are made by a player to serve as a representation of him- or herself, while player-characters are created during the game's development. While this distinction also matches Boudreau's definition, Woodford takes that distinction further and subdivides representations of players into four categories. The first is the traditional avatar, defined as a "physical representation of a player's representation in a virtual environment" that can be moved around in this environment. Further, "the player has substantial control over the appearance, attributes and role that their representation begins with and develops."[56] The second category corresponds to the player-character and is similar to the first except that "there tends to be a less open structure to the game, with the player following a predefined, often linear, narrative, and the character developing during the narrative in a way that was established prior to them starting to play."[57] This description applies well to characters such as Mario from *Super Mario Bros.* or Link from *The Legend of Zelda*. It also has some application to fauna. The only major way a fauna could develop during play was by finding a special "gene" that would allow it to enter previously inaccessible areas. Such genes were designed into the game prior to play and hence correspond to Woodford's last point about this category.

The third category Woodford describes is the "textual avatar found in a textual virtual environment," meaning the character controlled by a player in a text adventure or text-based multiuser dungeon. The last category addresses the role of the player more so than a representation of the player and includes games where "the player's representation is either implied, or is otherwise not portrayed in a virtual environment. In these games the player often still internalizes a role, whether that be a god-like control over an environment and the agents who act within that environment or the portrayal of a specific role . . . who does not warrant or require a physical representation in a navigable space, but still exists as an entity within the game world, with the ability to develop characteristics and be referred to by other agents."[58] While Woodford's second category best describes fauna, this last category describes how players of *Faunasphere* interacted with the game world and their roles therein. As caretakers they were not represented in the game's navigable space, but they were able to act within that space. Many nonplayer characters in the game, such as the humans who provided tutorials and gave quests, would address the player directly. This is of course similar to the role played by players

of games such as *SimCity*, where the player is the mayor of the city; *Sid Meier's Civilization*, where the player takes on the role of a historically significant leader; or *Railroad Tycoon II*, where the player is a railroad speculator and investor. Of course, all these roles are fictional and do not adequately describe the range of potential actions available in each of these games, just as "caretaker" is similarly insufficient to describe *Faunasphere* players. However, these roles are significant in that they frame and contextualize the player's actions and motivations. This last category also addresses the multiple characters problem, as it allows for players to act on and through multiple agents (such as troops in a strategy game) while maintaining their own role (such as a military general).

Still, a defining trait of *Faunasphere* was caretaker–fauna integration. *Faunasphere* integrated Woodford's second and fourth categories, causing players to sometimes act primarily through a player-character and sometimes to act primarily as their own character, a caretaker. At this point, it is tempting to follow the thinking of James Newman, who offers a very different approach to understanding how a player relates to his or her activities within a game: "Expanding on Friedman's work on *SimCity* and *Civilization* . . . it is possible to go further and suggest that the very notion of the primary-player relating to a single character in the game-world may be flawed. Rather than 'becoming' a particular character in the gameworld, seeing the world through their eyes, the player encounters the game by relating to everything within the gameworld simultaneously."[59] Newman argues that the player necessarily experiences the game from a distance, rather than from the subject position of a character or avatar, which allows him or her to relate to and experience the game as a whole. This theory seems to accurately describe how *Faunasphere* players were able to alternate between playing with and through a character and through the mouse cursor. Newman's theory draws its strength by not privileging any aspect of a game over any other, but this is also its weakness. The players of *Faunasphere* may have related to everything equally, which enabled them to operate in so many roles simultaneously, but they clearly valued and emphasized some aspects over others; the word *relate* here is ambiguous. To reduce players' interaction with and attachment to the game in this way does not do justice to the sense of loss they experienced when their fauna ceased to exist.

What we have demonstrated in this chapter is that the many theories and models of avatars and player-characters are built on specific games or genres, and despite being presented as useful in a general sense, they do not work well outside their originating realms. This echoes the findings of

Carter, Gibbs, and Arnold, whose study of *EVE Online* players showed that identity construction is strongly shaped by game design.[60] This was true of *Faunasphere* as well, where the players' identity as caretakers was shaped by the game's fiction and by the nature of player–fauna interaction. Fauna combined attributes of virtual pets (which engendered player attachment) and player-characters (which enabled players to interact with the game world through them). Such mixing and combining is common practice in game design, which can be problematic for the creation of overarching taxonomies or frameworks. By instead taking a phenomenological approach to games, we can account for how specific design decisions affect specific players.

Conclusion

Fauna were an essential aspect of *Faunasphere*. They enabled the player to navigate and interact with the world and were a source of play in their own right. The survey responses and Facebook posts we have highlighted throughout this chapter show that players became emotionally attached to their fauna and continue to mourn their loss. This attachment derives from the fictional framing of the game and the nature of the player–fauna interaction. Players were framed as "caretakers" charged with caring for their fauna. The game addressed players directly, thus discouraging players from identifying with their fauna as representations of themselves. Playing the game involved questing and adventuring through and alongside one's fauna, turning them into play companions. While this play was presented as a nurturing act, it lacked the gravity of interacting with *Tamagotchi*: Fauna would not die from lack of attention.

Fauna shared some functional qualities with avatars and player-characters but problematized many theories of both. They were sometimes the means by which players interacted with the game, but not always. They were used to communicate with other players, but players were not bound to them in the fashion typical of MMOGs, removing the potential for them to be essential to online identity and community. Fauna were more customizable than player-characters but less so than avatars. In other words, none of the theories of either phenomenon examined adequately described fauna. This is because fauna were an uncommon type of game object combining aspects of avatars, player-characters, and virtual pets. This further suggests that studies of controllable game characters need to take the player's role into account and not just focus on the game.

As a hybrid creation, fauna reinforce one of the major themes of this book: that novel game forms can disrupt existing theories of games, especially when those theories address a wide range of phenomena. The avatar theories discussed here cover everything from two-dimensional images attached to a forum poster's username, to highly detailed three-dimensional characters in console videogames, to user-created characters in virtual worlds and MMOGs. It is of course impossible for media and game studies theory to address all possible future configurations, but this highlights the need for close and detailed examinations of existing games. As Jon Peterson observes in his mammoth history of *Dungeons & Dragons*, "The various practices we group under the word 'games' share surprisingly little in common."[61] While this presents a problem for theories that attempt to encompass "games" generally, it is also an opportunity. We believe that close, detailed studies of individual games are critical at this early stage in the development of game studies because, as Peterson observes, the breadth of "games" is so great that knowledge of a great many phenomena and artifacts is required to think about "games" generally. Outliers and experiments like *Faunasphere* are especially important in this regard, as they have the potential to capture new audiences via unconventional design decisions but are also easily overlooked by academia and the press alike. *Faunasphere* and its fauna are an example of a novel game form that, while not commercially successful, nonetheless made an enormous impact on its players. Understanding how *Faunasphere* accomplished this teaches us more about how games can not only be meaningful but also instill in players deep emotional attachments to simple virtual creatures.

Saying Goodbye to Rock Garden

Never again will I allow a single game to make me passionate about it.

—DON

It's an unusual experience to write about a game that can no longer be played, with forums that have officially disappeared. Player memories linger on, and the game's most dedicated fans continue to reminisce, although in dwindling numbers and with increasingly less frequency. Details become fuzzy about how certain gameplay elements functioned, and things that seemed innovative or novel at the time now are either passé or so widely embraced as to be unremarkable. Yet *Faunasphere* was (and remains) a special game and an important experience for a variety of reasons, and our study of it has significant ramifications for game studies, including how we conceptualize player activities as well as the contexts of gameplay.

Player Activities and the Inadequacy of Typologies

One of the findings we believe is most significant relates to the dynamic and complex nature of player activity. Although we started our study intent on questioning how players spent their time in the game (and, to be honest, intent on showing how female players were interested in much more than socialization), we have left this project even more convinced of the uselessness of player typologies and charts of interests by gender, age, or any other demographic marker. Certainly players will rank activity preferences if asked or can even be observed or logged going about different

game actions. We could even construct a rough typology drawing from Bartle's model, placing the players into a grid. Yet as we learned through careful observation over time and changing contexts, those activities do not happen in a vacuum. Players are always and continually responding to a multitude of inputs and contexts as they go about their play. Players are responding to the newness of the experience—for them or for the life of the game. They are acting in relation to daily goals or interests they have built in the game, they are acting in response to (in tandem with, in opposition to, in defense against) other players, they are considering their future (or not) in the game, and they are responding to many other things we likely cannot measure. None of these can usefully be collapsed into a chart or framework that purports to demonstrate "how players play" in any way other than at *that specific moment in time.* Yet that specific moment in time means nothing outside of the larger context of play. *Faunasphere* players taught us this, as they moved from beta to open release, through Facebook integration and the game's sunset. Player activities changed in response to all those events, and we could not understand gameplay without adequately taking into account all those contingencies.

Faunasphere also demonstrated how player typologies and frameworks for understanding motivation and activities can easily become fiction dependent, even within a game genre. Achieving game-provided goals in *Faunasphere* likely means something other than doing so in *World of Warcraft,* because the fiction that frames those activities is so different. Leveling up a hoofer or an orc warlock may both require grinding, but the activities that constitute grinding are very different and consequently shape a player's interest in performing those activities. This further calls into question the validity of thinking of massively multiplayer online games (MMOGs) as a genre: While these games have many formal and structural tropes in common, different content can make for a very different kind of game.

Likewise, the importance of a game's fiction suggests that the privileging of game rules over fiction is a mistake. While Bogost, for example, makes key points about the importance of procedural rhetoric in shaping player choices,[1] *Faunasphere* demonstrates the necessity of understanding how fiction is imbricated in the meaning players make and take while manipulating game systems. Sicart argues that in proceduralist thinking, players become mere "activators" of game meanings, and instead we should think of players as far more free, able, and willing to make their own paths through gameplay and game systems.[2] We would agree that players are much more than activators of a game's system but that they are also reacting to platforms, temporal issues, and a complex interplay

of fiction and mechanics. So players are not simply trying to optimize a system by exploiting rules; instead, they are negotiating complex configurations that rarely stand still, just like the players themselves.

Problematizing Broad Theories

Throughout this study, *Faunasphere* has demonstrated the problems with theorizing broadly about games as well as media more generally. Not only was this true with regards to player typologies and theories of player motivation, it was especially the case when it came to trying to understand the deep emotional attachments players formed to their fauna.

The question came about after *Faunasphere* had already closed, and we began reading interview after interview where the respondent expressed a deep sense of loss over their fauna. When we were playing the game ourselves, fauna had seemed unexceptional: Functionally, they built on preexisting conventions and therefore were intuitive and straightforward to use (at least for experienced game players). It was only after we began trying to understand how they fostered such attachment that their hybrid nature—part player-character, part virtual pet—came to light. However, coming to this formulation in turn showed us that our understandings of self-representation in a virtual environment are still far from complete. Scholars interested in "avatars" or "player-characters" have used these terms to describe many different phenomena in equally many different contexts, leading to a dilution of these terms that limits their analytic usefulness. We believe that at this early stage in the history of networked virtual environments, detailed and nuanced studies of such phenomena are more productive than all-encompassing theories; the term *avatar* needs to be retired.

We realize that a theory cannot be expected to account for all future possibilities and that theories are naturally revised and refined over time. But what our work on *Faunasphere* has demonstrated repeatedly is that subtle variations in an established game genre can deeply problematize already accepted theoretical frameworks. We believe that this is because game studies so far has largely focused on artifacts that have been commercially or critically successful. However, commercial success in the videogame industry has historically been more about emulation than variation, and as a result, the games at the bottom of much game studies theory are very similar to each other. Narrow studies of uncommon outliers, as we have tried to demonstrate here, can ironically broaden our understanding of what games are capable of by calling attention to how

variation and nuance can have wide-ranging effects. *Faunasphere* players were *caretakers*, and this seemingly minor detail made all the difference.

The Contexts of Play

Being able to see the lifecycle of a game is something unique—particularly for games that are not designed to end. Because of the short lifespan of *Faunasphere*, we were able to witness the close of the beta period, the game's public release, a rerelease on Facebook, its sunset, and the aftermath. As we write this, games much older than *Faunasphere* are still operating— *Final Fantasy XI* launched in 2002, *World of Warcraft* in 2004, and even classics such as *EverQuest* and *Ultima Online* have viable player bases that engage in regular activity. Obviously they will have quite different player cultures, experiences, and contexts for play than *Faunasphere* did, but either way, what we learned is instructive to consider when studying MMOGs. Just as players cannot be pinned down and held in isolation to determine their "interests" or "activities" apart from larger contexts, neither can we say much about *World of Warcraft*, for example, without also contextualizing the game itself: how long it has been operating, how long has the average player been active, have there been any major changes in the player base, and so on.

It is also important to contextualize the platform the game runs on. In *Faunasphere*, we found not only that the fact that the game was accessible via Facebook shaped player expectations for the game but that those expectations were themselves historically situated in the larger context of the development of the platform. Had Facebook been more popular with a different demographic, or if Zynga had never established the "build and harvest" paradigm then typical of Facebook games, the consequences of the Facebook launch would likely have been very different. Just as players and games are not static entities, neither are the platforms supporting the games. This is just as true for hardware platforms as well as software: Both are subject to audience beliefs and expectations (such as the association between Nintendo consoles and child-friendly titles), and both go through a lifecycle from novelty to obsolescence. As a hypothetical example, imagine a scenario where Blizzard ceases to update *World of Warcraft* and the game eventually stops working on contemporary hardware. Regardless of the popularity of the game at that future time, this would have a major impact on the game. Only the most dedicated players would be willing to spend the time and money acquiring and maintaining the necessary obsolete equipment, which would likely lead to a homogenization of the

in-game culture as the number of less-dedicated players diminishes. Game worlds and the cultures found within them are highly emergent phenomena,[3] which means that understanding them fully requires understanding as many of the forces that shape them as possible.

"What about the Men?"

Although we have mentioned it in limited ways throughout this book, we want to revisit here the demographic breakdown that we found in *Faunasphere*'s player base. *Faunasphere* was a game played predominantly by adult women. Some men were present, as were some children and younger players, but older adult women formed the core of the player community. This was reflected in the interviews we did, the forum posts we studied, and our survey results. One of our key goals was to contribute to a better understanding of such players, who are not (yet) active across many different play genres and spaces. Yet even as we wanted to highlight and investigate their presence, we didn't want to reduce their experiences to one element of their identity. Why? Because although we do believe that gender is an important concept in understanding players and play activities, and older adult women are indeed worthy of study, gender was not the only salient element that we found in this study.

One of us (Mia) has been researching women and games for almost a decade, and even her early research found differences in play styles and attitudes between women who were heavy players and those who played moderately.[4] Other early researchers such as Taylor have written about how female players like to achieve mastery in online game spaces such as *EverQuest* (rather than simply be social), and Delamere and Shaw documented female *Counter-Strike* players who played more hours per week (34 hours) than the men (21.5 hours) they studied.[5] More recently we have witnessed the rise of casual and social games, which draw a larger female demographic than triple-A console and PC games historically have. But we cannot and should not look for how gender draws all those players and game designs together. To simply conclude that "*this* is how women play" would fall into the fallacies suggested by Jensen and de Castell—ascribing timeless traits to women that simply aren't present.[6] But some elements of gender do deserve some deliberation now, in thinking through how the game and its community evolved and how we think about players more broadly in game studies.

Big Fish built *Faunasphere* with its existing core audience of adult female players of casual games in mind, if only as a base for building an

even wider audience via Facebook.[7] And the game design contained many elements that appear stereotypically feminine—a lack of killing and combat with instead a focus on raising and nurturing small creatures, as well as opportunities to build and decorate personal spaces and socialize with others. Early players further compounded that focus, building a "culture of niceness" and an expectation of politeness as well as being helpful into regular play. Yet at the same time, players also vociferously complained when they felt children were "invading" their game space, which they had deemed for adults only. Many players we talked with felt that *Faunasphere* was supposed to have more definite boundaries based on age restrictions— that it would be a space where they could play alongside other adults and do as they pleased (solo or with others) without the constraints of their daily (gendered, social, and work-related) lives following them.

Janice Radway discovered similar attitudes among female romance readers, finding they had constructed their novel-reading time as an activity solely for their benefit and enjoyment, asserting their right to do so, and making claims on their time that were nonnegotiable. But they were also reading texts that were decidedly patriarchal and sexist in tone.[8] Those two actions were in tension with one another, yet Radway would not privilege one element over the other. We can also ask if such comparisons apply to players of an online game more than thirty years later. *Faunasphere*'s design, including both its mechanics and its fiction, was created to attract casual gamers, a demographic that fit Big Fish's already existing female market, but the game did not have the same patriarchal themes that Radway found in romance novels of her era. Perhaps instead we could argue that *Faunasphere*'s players were similar to romance readers in wanting their own space but via a more contemporary context—one with shared roots in similar animal-themed games (such as *Tamagotchi*) that have not been associated with such gendered or sexualized connotations.

In closing, we would like to call for more games research that situates gender not as the prime object of interest but as one taken as part of the larger context. Thus this is not a study of female game players, but it does take gender as one key focus in tandem with others. Likewise, many studies of other MMOGs that purport to study "players" but instead largely focus on male players must be more honest about the player base they are examining. Player gender may not be the most interesting or important factor in a study. Likewise, as we have shown, women are not a genre or monolithic demographic group. Even if it was adult women who created a culture of niceness in *Faunasphere*, there were other adult women (and younger women) who saw the game as more akin to the "build and

harvest" games that Zynga popularized and thus approached the game in a more transactional manner. In sum, gender matters—but only as part of a larger system—and it matters just as much for men as it does for women.

The Value of Studying Unusual Games

In closing, we want to make two final points. The first is that in some ways we have been fortunate that *Faunasphere* was much smaller than most MMOGs, in terms of the size of the game world, the number of players, and the amount of time it was open. Throughout this book, we have argued for the value of considering not just the players or game design in trying to understand an MMOG but also the myriad contexts that shape and inform it. We fully acknowledge that this project was viable for just the two of us to conduct in part because the game was so small. A similar study of a game like *World of Warcraft* or even *EVE Online* would necessarily entail more time and effort, and attempts to study the majority of a game's lifecycle will almost always be fraught with uncertainties and difficulties, as there is no way to know if and when a given game will end. Despite this, we have shown throughout this book that digging deeper into the contexts influencing the game, its players, and the platform is necessary for researchers seeking to gain a fuller understanding of an MMOG.

Our final, and most important, point is the value of studying novel or unusual kinds of games. *Faunasphere*, through its synthesis of MMOG and casual game elements, was something different from its contemporaries. Much more complex than Big Fish's match-3 and hidden-object games, much simpler and more peaceful than other MMOGs of the time, *Faunasphere* not only stood out in the marketplace but also stood out among the kinds of games that game studies scholars have examined so far, and as a result, it has challenged many of our assumptions and understandings. Although MMOGs have not varied much in their short history, *Faunasphere* suggests that more variations and experiments are forthcoming, and game studies scholars need to be attentive to these games, perhaps even more so than the next commercial smash hit. In trying to understand a medium, or even a genre within that medium, attending to variation is crucial.

Commercially speaking, *Faunasphere* was a failure. It did not make enough money for its developer to view it as a sustainable venture—nor did it have enough cultural impact to be the subject of a *South Park* episode. But for these same reasons, it was invaluable.

In many ways, this book illustrates both the importance of videogame preservation generally and the difficulty of writing about massively multi-player online games (MMOGs) specifically. As of the time of this writing, *Faunasphere* only exists in the fleeting memories of its players and the artifacts they have created, such as the Faunasphere Wiki, the Fauna-sphere Memories Facebook group, and countless videos on YouTube. That MMOGs have such lifecycles, unlike more traditional videogames where the player actually owns a physical copy, makes them fascinat-ing and important objects of study. In this case, we were fortunate to have been present in *Faunasphere* for almost the entirety of the game's existence. At the same time, however, one of the consistent challenges of writing this book has been the fact that our readers will be unable to play the game for themselves. Not only does this mean that the world is not there to be experienced, but simple yet essential pieces of information that are easy to take for granted have been lost as well. How fast did fauna run? How many mouse clicks were needed to buy something from the marketplace? What angle did the players look down at the world from? What sound did a newborn fauna make when it hatched? While all these details seem minor, all of them contributed to the overall experience that was *Faunasphere*. Throughout this book, we have endeavored to describe the workings of the game well enough to make our points but not so much as to bog down in detail. Because *Faunasphere* is no longer active, however, we also wanted to include a fuller gameplay description. This is partially in the interest of preserving information about the game and partially so the interested reader has access to this information. In service of these goals, we have included this appendix, which describes the major elements of the game in detail.

Background

Faunasphere presented players with a bright and colorful world wherein the player took on the role of a "caretaker." In the game's backstory, caretakers were people who had come to the world to clean up the rampant pollution and take care of the native creatures. This narrative context was primarily delivered through the game's tutorials, and while it rarely surfaced elsewhere in the game, many players took the role of caretaker seriously. *Faunasphere* ran in Adobe Flash, it was two-dimensional with an isometric perspective, and interaction with the game world was mouse driven. Clicking on the ground caused the player's character, known as a "fauna," to run to that spot. Players could also click on objects in the environment to interact with them. For example, a player might click on a tree, causing their fauna to shake it until food fell out. There were many interactive objects placed throughout the world, some of which had a natural appearance, while others had an artificial look. The former included things

FIGURE 11. The Rock Garden in *Faunasphere*. The metallic dome projecting an image is a gate, which was used to travel to other areas.

such as the aforementioned tree, tree stumps, ponds, and so on. Fauna needed special abilities in order to interact with these, such that each kind of fauna could only interact with a handful of them. For example, a hoofer could shake trees but could not dive into a pond to look for items. The second category we label "artificial" because unlike the former, they appeared as machines or electronics that, in terms of the game's fiction, were not naturally a part of the world. These included things like gates (which connected different parts of the world), merchants, goal stations (where players could take on quests), and the canopy, which is described later.

Fauna

The main job of a caretaker was to raise diverse types of "fauna." Fauna were colorful, cartoonish creatures based on animals and given descriptive names. The horse fauna was called a "hoofer," the cat a "scratcher," the dog a "sniffer," and so on. Fauna had an energy level and a happiness level (these are represented by the two bars in the bottom-left corner of Figure 11). As a player played with a fauna, it would slowly lose energy, and once its energy was depleted, the fauna would begin moving very slowly and refuse to perform any actions. Players could replenish their fauna's energy by feeding them or letting them rest in a den. Happiness was similar: If a fauna ran out of happiness (which only happened from battling pollution), it would automatically be sent home to the player's personal area, which was known as a "faunasphere," or "sphere" for short. Happiness could be regained by giving the fauna food it liked or letting it sleep in a den that it liked. How a fauna felt about various objects in the game, especially food, was very important, which led some players to construct and maintain spreadsheets cataloging how each fauna type felt about each kind of food and material. The Faunasphere Wiki lists 210 different kinds of food that were available. If a fauna was directed to sleep in a den made out of materials it did not like, it would actually lose happiness. There were many different kinds of food (usually appearing as fantastic produce such as "taterbeans" and "bacoberries"), each of which appealed more to some fauna and less to others. Giving a fauna food it disliked would lower that fauna's happiness, so managing one's food inventory was very important. To aid players with this, it was possible to plant food-bearing trees in one's sphere to ensure a steady supply.

Each fauna had a set of characteristics that defined how it looked and what it could do. Appearance characteristics included the color and pattern of the fauna, as well as a specific kind of tail, eyes, and eyebrows (the set varied by fauna). As an example, one of the authors' fauna was a

white pouncer with a "straight tail," "Buster eyes," and "short ears." This fauna is shown in Figure 12. Fauna could also have different "genes," which gave them various abilities. If a player wanted to take his or her fauna into an icy climate, that fauna would need the "coldproof" gene. Genes were named as such because when a fauna laid or incubated an egg, they would be passed down to the fauna's offspring.

During the game, players were able to change the fauna they were controlling at any moment they chose without logging out, going back to their home sphere, or even moving to a different location. This meant that players could not reliably identify each other based on fauna, an effect amplified by the fact that players were frequently hatching new fauna to use. As a result, the game displayed the players' account names over their fauna, thus allowing players to identify each other. Although players would name a fauna when it was born, that name was only visible to its owner. In-game progress was tied both to individual fauna (which could reach a maximum level of twenty) and to the player's account. Players could use any fauna they wished to complete quests (provided the fauna had the necessary genes), and the quest would still count as having been completed if the player switched to another fauna. The player's inventory was also tied to the account, not to any one fauna.

Fauna were also able to perform tricks, akin to the various animations available to *World of Warcraft* avatars. These were short, predesigned

FIGURE 12. A white pouncer with Buster eyes, short ears, and a straight tail.

animations that a fauna could learn over the course of gameplay, and they were unique to each kind of fauna. Examples include various flips, scratching, hopping, rolling, stomping, briefly hovering midair, and so on. Tricks had no value other than aesthetic, and several players reported having fauna perform tricks for either their own amusement or that of other players; at the game's closure, many fauna could be seen performing their tricks up until the end.

Although players primarily interacted with the game via their fauna, there were times when interaction was done directly through the mouse cursor. For example, building one's sphere was done through menus and a separate interface that omitted fauna use entirely. Additionally, to use the marketplace (to buy and sell items), a player first had to click on an access point in the world, which would cause the fauna to move there, followed by the opening of the marketplace interface. Thus playing *Faunasphere* required players to continually move back and forth between interacting with the game via their fauna and interacting with the game directly.

Pollution

A major part of playing *Faunasphere* was earning levels to acquire eggs. As with many games with role-playing elements, every fauna had a "level," and by earning experience points (XP), they could go up in level. There were two main ways of earning XP: completing goals and zapping pollution. Goals were essentially quests, albeit very short, and often took the form of finding items hidden throughout the world. Pollution appeared randomly throughout the game world and looked like green or black gaseous cubes.

By clicking on a pollution cube, players could direct their fauna to "zap" it using the special collar or harness with which all fauna were equipped. After several such zaps, the pollution would vanish and the fauna would earn XP. Some pollution was capable of fighting back by depleting a fauna's energy and happiness. All pollution was stationery, however, so it was easy for players to avoid or retreat from pollution.

Pollution was also tied to the game's backstory: As mentioned before, upon creating a new account, players were told that part of their mission in *Faunasphere* was to clean up the rampant pollution. This backstory was drawn on again when the game shut down: For a short time after the sunset, the game was replaced by the image in Figure 13, which explains that the game is over because all the pollution has been cleaned up.

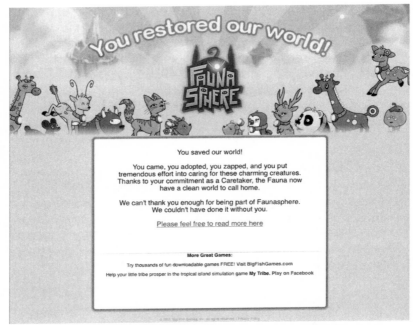

FIGURE 13. For a few months after the game shut down, attempts to access it were directed to this web page.

Eggs

Zapping pollution was an easy way to level up one's fauna and hence was a popular activity. When a fauna reached a new level, it would lay an egg, which could then be hatched to give the player another fauna. Eggs could also be traded or purchased, and eggs from rare kinds of fauna, or from fauna with rare abilities, were highly prized.

Breeding new fauna was another major part of the game. To do so, players took an existing egg and chose a fauna to "incubate" it. The fauna that laid the egg and the fauna that incubated it were effectively the parents of the new fauna (although a fauna could incubate its own egg), which would then influence what kind of fauna it was and what its various characteristics were. For example, the new fauna might take the same eyes as one parent and the same tail as the other. Breeding had a random element as well, as two different kinds of fauna could sometimes hatch a third kind—that is, a sniffer (dog) and a scratcher (cat) might hatch a hoofer (horse). This seems to have been done to allow for the introduction

FIGURE 14. New fauna took on some characteristics of their parent fauna, and one fauna could both lay an egg and hatch it, although that led to less fauna diversity than crossbreeding.

of new kinds of fauna: Periodically the game would update and make possible hatching new breeds. Such updates would always lead to a race among the more dedicated players to be the first to hatch the new fauna, and eggs laid from these new fauna were among the most valuable items.

Because eggs were so frequently circulated—there was no value in holding on to an egg because they depreciated as new fauna types were introduced—new fauna were not necessarily the product of one player or another but often a product of the community as a whole.

Currency

Experience points were also tied to the game's basic currency, "lux." When a fauna earned XP, the player also earned lux in equal amounts, which could then be spent on items at the marketplace or another player's totem. *Faunasphere* also had a premium currency known as "bux," which were available via one-time purchases and were prorated such that the larger a purchase was, the cheaper bux became. Additionally, the game featured tiered monthly membership levels. A free membership allowed a player to own three fauna at a time, while paying for a higher-level membership allowed a greater

number of fauna to be owned, gave a discount when purchasing bux, and also came with a monthly distribution of free bux. The different currencies were important, because players could list items for sale in the marketplace by paying a small fee, and the currency used to pay the fee determined the currency needed to buy the item. As such, players who were paying for a premium account typically placed rare eggs and items in the bux marketplace. There were also items available for purchase directly from Big Fish Games, such as hats, and these required the use of bux. As with items, lux and bux were associated with an account, not a particular fauna.

Spheres

When a player started the game, he or she would begin in his or her sphere, where all his or her fauna would be present and could be seen walking about the space, occasionally performing tricks and displaying other simple animations (Figure 15). These fauna could also be "hidden," which meant that instead of seeing them in the sphere, they were not displayed. This option was included because a sphere could have up to twenty-nine of these uncontrolled fauna, causing older computers to run the game considerably slower.

Spheres were in fact not spherical at all but were made up of numerous cube-like "blocks" that could be fit into a preexisting grid at various heights. This meant that they were highly customizable: While initially

FIGURE 15. Inside a sphere.

appearing as a small, floating island, players could extend their usable space by finding blocks in the game world and then adding them to their sphere. In fact, the majority of the game world appeared to be constructed of these same blocks, but because the world was static, the artists and designers were able to embellish and customize it with a level of nuance unavailable to player spheres. Many different kinds of blocks existed in the game: grass, path, stone, snow, water, ice, and so on. In addition, it was possible to obtain many different decorations, especially holiday themed, that could be placed in one's sphere.

Spheres contained two important places for a player's fauna. First was the den, which was one of the first constructs players were taught how to build during the tutorial. A den was where a fauna could rest if its energy or happiness was depleted, and in fact, it was often necessary to have several different dens to cater to the preferences of different kinds of fauna. The second was the nest, which was required to hatch a new fauna from an egg.

Spheres also contained "totems," which might best be described as item factories (but appeared as large stone statues). By spending lux, a totem could be made to produce one of several different items (a given totem always produced the same item). These items would then be available for other players to purchase. A player could never acquire items out of his or her own totem; totems were thus automated factories that would continue to produce items so long as their owners continued to supply lux. If a given player purchased enough items out of a totem, he or she would become a "patron" of that totem. Interestingly, totems also had a place for visitors to leave gifts. The players of *Faunasphere* quickly established a custom where, upon earning "patron" status, a player would leave a gift for the totem's owner. Where this came from is unclear, and it was rather strange in that it was analogous to giving a grocery store owner a free gift after you have purchased enough carrots from them; one would expect this to happen the other way around. Regardless, this custom was important to many of the players, as was the general culture of giving that emerged during beta testing (see chapter 2).

Items purchased from totems did not have immediate value; rather, they were used to earn tickets at the "canopy," a centrally located structure that was the hub of the raffle system. Over the course of a raffle period, players would donate items purchased from totems to the canopy and receive virtual tickets in exchange. The canopy required a certain number of each item type to be donated, and once an item's limit was met, no more could be donated. Once all item limits were reached, the raffle would be held and players could win a variety of items that could be used

in the game. The canopy would then be reset, and each time the required number of items per type would be changed.

Spheres also featured a "friend gate," which was used to visit the spheres of players on one's friend list. It was also possible to visit spheres of users not on one's friend list by traveling through the sphere of a mutual friend, which made it possible to explore through long sequences of spheres. Although the only possible interaction in another's sphere was to buy items from the totem, players would organize semiregular games of "hide-and-seek," where a player would hide in a sphere, and the others would attempt to find him or her through the friend gate system.

Daily Gameplay

Faunasphere's main activities consisted of leveling fauna, breeding new fauna, decorating spheres, and participating in the game's various events. As with many MMOGs, *Faunasphere* featured seasonal activities, including special goals to complete for Halloween or Thanksgiving as well as items to buy that reflected holiday or seasonal themes. Likewise, the game's developers regularly ran contests for best-decorated spheres based on those time frames to encourage players to regularly update their personal spaces. The game also featured goals that were story based as well as chains of goals for players who were invested in the game's storyline. However, those elements were minor compared to the central activities of the game, which focused on taking care of and breeding new fauna, managing one's personal sphere, and interacting with other players.

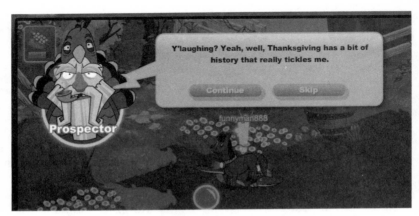

FIGURE 16. Special items and characters made seasonal appearances in *Faunasphere*, such as for Thanksgiving.

Introduction

1. Juul 2010; Kultima 2009.
2. Juul 2010.
3. Williams et al. 2009.
4. Juul 2005.
5. We had been approached by Big Fish Games in early June 2009 after they read an article Mia had written that examined the player base for one of the games in their *Mystery Case Files* series. They were interested in collaborating on a project exploring their players' interests and habits, and we agreed on *Faunasphere* as an appropriate site for study. During the first two years, BFG provided us with some basic user gameplay data and access to a moderator for a short interview, and they agreed to host and promote our initial survey. They also gave both of us a premium account for free, which allowed us to each have multiple fauna within the game. After the survey was completed, we shared the data with them, and we then had no further contact. When the game was slated for closure, we did not hear anything from the company about it. Over the course of our research, the original research director at Big Fish left the company, which likely led to subsequent silence from Big Fish.
6. Consalvo 2011.
7. Pearce 2009, 28.
8. Yee 2006.
9. Lee and Wohn 2012; Rossi 2009; Wohn et al. 2011; Wohn 2012.
10. Consalvo 2007.
11. Taylor 2006.
12. Kultima 2009.
13. Juul 2010.
14. Paul 2013.

15. Linderoth 2005.
16. Montfort and Bogost 2009.
17. Jenson and de Castell 2010, 56.

1. Introducing the Caretakers

1. Pearce 2009.
2. Juul 2005.
3. Taylor 2006.
4. Nardi 2010; Chen 2011.
5. Bartle 1996.
6. Yee 2006.
7. Consalvo 2009.
8. Juul 2010.
9. Jenson and de Castell 2010, 56.
10. Bartle 1996.
11. Yee 2006, 772.
12. Yee 2006; Williams et al. 2009.
13. Yee 2006, 774.
14. Williams et al. 2009, 716–17.
15. Ibid., 721.
16. Taylor 2006.
17. Juul 2010.
18. Consalvo 2009, 53.
19. Kuittinen et al. 2007, 110.
20. Juul 2010, 156.
21. Ibid.
22. Ibid.
23. Consalvo 2009.
24. Yee 2006.
25. Taylor 2006.
26. Williams et al. 2009.
27. Ibid.
28. Thirteen respondents answered N/A.
29. Almost all social games follow this model, with the best-known examples including *FarmVille*, *Mafia Wars*, *FrontierVille*, and *Social City*. Free-to-play MMOGs include *Maple Story*, *Puzzle Pirates*, and *Habbo Hotel*, although even MMOGs that once charged monthly membership fees are now experimenting with this model, including *The Lord of the Rings Online* and *Dungeons & Dragons Online*.
30. Two respondents answered N/A.
31. Yee 2005.
32. Meretzky 2010.

33. We did not have membership breakdowns from Big Fish Games to make a comparison with our survey respondents.

34. Yee 2007.

35. Williams et al. 2009.

36. Yee 2006.

37. Favorite activities differed slightly between platinum members and free members. "Completing Goals" was the top activity for both platinum and free members, with 35 percent of platinum members rating it as a "top three" activity and 39 percent of free members doing the same. However, while 32 percent of platinum members rated "Breeding Fauna" as in their top three, only 22 percent of free members did so. That may be because free members were limited to caring for only three fauna at a time—thus breeding multiple fauna was a challenge. Finally, 33 percent of platinum members rated "Leveling Up" in their top three, and 39 percent of free members did so as well. Despite small differences in the ranking of these three activities between free and paying members, however, they were still more popular overall with all members than the other alternatives, which included decorating one's sphere, participating in raffles and patronage, and socializing with friends.

38. Yee 2006.

39. While this is an area we did not formally study, it became clear that players learned to play this game via either trial and error or consultation with other members, or more likely a combination of both. Early beta testers of the game were largely drawn from membership at the Big Fish Games site, suggesting that the players mentoring one another were mostly women. This finding is similar to Taylor and Witkowski's (2010) observation at a Swedish LAN party that female players were starting to mentor one another rather than relying on male mentors, as past generations of female players have done. Similarly, Kolos (2010) found the beginnings of female mentoring of gameplay in a college setting. We believe such activities are important and in need of further attention, although at this point, we cannot make any conclusions about how this might have affected players' play styles, activities, or interests.

40. Taylor 2006.

41. Williams et al. 2009.

42. The premium currency, bux, is not included in this model because it is entirely optional. Players had to invest real-world currency to earn bux, and as such, it is not part of the reward structure.

43. Yee 2006.

44. Juul 2010.

45. Kultima 2009.

46. Juul 2010.

47. Begy and Consalvo 2011.

48. Consalvo 2009.

49. Juul 2010.

2. Those Were the Days

1. Rainier 2007.

2. Cook 2009.

3. See more information at http://www.mmorpg.com/gamelist.cfm/game/491/view/reviews/load/98/page/1; http://www.doublegames.com/mmorpg/faunasphere.html; http://www.mabelgames.com/faunasphere.

4. Note that we have continued our tradition of using pseudonyms for all players we cite, despite this forum thread being publicly available online (at least at the time of this writing).

5. Kucklich 2005.

6. Paul 2012.

7. Sotamaa 2009.

8. Paul 2012, 37.

9. Ibid.

10. Pearce 2009.

11. Consalvo 2007.

12. Paul 2012.

13. Taylor 2006.

14. Pearce 2009.

15. Juul 2005.

16. Juul 2010.

17. Pearce 2009.

18. Paul 2012.

19. Miller 2010.

20. Harris, Patterson, and Kemp 2008, 226.

21. Olick 1999, 339.

3. Shifting Platforms and Troubled Ground

1. Although the existence of such a high-profile book series might suggest that the topic receives regular and sustained attention within game studies, that is not really the case. Prior to the series, the subject of platforms was rarely addressed at game conferences such as those of the Digital Games Research Association or via journal articles in high-profile spaces such as *Game Studies* and *Games and Culture*. In those spaces, much more attention has been paid to issues of gender, culture, representation, and narrative.

2. Montfort and Bogost 2009, 2–3.

3. Evans, Hagiu, and Schmalensee 2006, 11.

4. Juul 2010; Kultima 2009.

5. Consalvo 2011.

6. Ibid.

7. The terms of use for *Faunasphere* are available at http://web.archive.org/web/20100322235648/http://faunasphere.com/company/terms.php.

8. Radway 1984.

9. Kendall 2002; Nardi 2010; Pearce 2009.

10. Taylor 2006.

11. Most likely because it had appeared as a mechanic in nearly every single social network game at the time (see Consalvo 2011).

4. The End of the World

1. Papargyris and Poulymenakou 2009.

2. Jenkins 2006.

3. A notable difference between Pearce's study and our project here is that she came to the *Uru* community after their original game had already closed.

4. Pearce 2009, 88–89.

5. Ibid., 89.

6. Papargyris and Poulymenakou 2009; Pearce 2009.

7. Pearce 2009.

8. As of January 2014, group activity had subsided somewhat and postings were more sporadic. They centered on major holidays and members reposting images from the game related to those events. In January there was also the news of the death of a longtime player of the game, and many tributes to her were given.

9. Bartle 1996; Yee 2006.

10. Bartle 2014, 13.

11. Ibid., 12, our emphasis.

5. "Why Am I So Heartbroken?"

1. Boudreau 2012; Gazard 2010.

2. Hamilton 2009; Klevjer 2006; Linderoth 2005; Murray 1997; Pearce 2009; Rehak 2003; Taylor 2006; Woodford 2009.

3. While other kinds of virtual pets have been the subject of extensive study, such as the AIBO (Kahn, Friedman, and Hagman 2002; Mival, Cringean, and Benyon 2004; Chesney and Lawson 2007a; Melson et al. 2009) and Furby (Mival, Cringean, and Benyon 2004; Turkle 2011), these are robotic toys and are very different from fauna. *Nintendogs* is closer to *Faunasphere* in that it is a software entertainment product, but it is offline and has far fewer game elements than *Faunasphere*.

4. Allison 2006.

5. Bloch and Lemish 1999.

6. Turkle 2011.

7. Allison 2006, 166.

8. Ibid., 176.

9. Turkle 2011, 32.

10. Ibid., 33.

11. Allison 2006, 181, italics in original.

12. Ibid., 183, italics in original.

13. Ibid., 175.

14. Turkle 2011, 32.

15. Bloch and Lemish 1999, 289.

16. Allison 2006, 176.

17. Turkle 2011, 31.

18. Allison 2006, 172–73.

19. Brown 2009.

20. Mival, Cringean, and Benyon 2004.

21. Boudreau 2012, 73.

22. Murray 1997, 113.

23. Pearce 2009, 21.

24. Ibid., 215.

25. Ibid., 241.

26. Ibid., 122.

27. Ibid., 111.

28. Klevjer 2006, 12.

29. Ibid., 10.

30. Ibid., 11.

31. Ibid., 14.

32. Ibid., 62.

33. Ibid., 64.

34. Ibid., 146.

35. Ibid., 118.

36. Ibid., 130.

37. Ibid., 135.

38. Ibid., 10.

39. Hamilton 2009, 5.

40. Ibid., 2–3.

41. Pearce 2009.

42. Hamilton 2009, 10.

43. McCloud 1993.

44. Hamilton 2009, 13.

45. Linderoth 2005, italics in original.

46. Boudreau 2012.

47. Linderoth 2005.

48. Boudreau 2012, 73.

49. Cleland 2008, 152, italics in original.

50. Boudreau 2012, 73.
51. Salen and Zimmerman 2004, 450.
52. Ibid., 453, italics in original.
53. Fine 1983.
54. Salen and Zimmerman 2004, 454.
55. Woodford 2009, 20.
56. Ibid., 31.
57. Ibid., 32.
58. Ibid., 32.
59. Newman 2002.
60. Carter, Gibbs, and Arnold 2012.
61. Peterson 2012, 204.

Conclusion

1. Bogost 2007.
2. Sicart 2011.
3. Pearce 2009.
4. Royse et al. 2007.
5. Taylor 2006; Delamere and Shaw 2008.
6. Jensen and de Castell 2010.
7. Big Fish was not the original creator of *Faunasphere*—Toby Ragaini's team at Thinglefin created the concept and started building the game as a free-to-play, browser-based casual MMOG. The game was an interesting departure from the developer's prior work as lead designer of *The Matrix Online*. Likely sensing the common audiences, Big Fish acquired Thinglefin in November 2007, and the game went through more than a year of additional development before entering closed beta testing in early 2009. So even if Big Fish did not create the idea for *Faunasphere*, the company was greatly influential in the game's final design and targeted marketing (Cook 2009).
8. Radway 1984.

Bandai. 1996. *Tamagotchi*. Bandai. Portable Electronic Game.

Big Fish Games. 2008. *Mystery Case Files: Return to Ravenhearst*. Big Fish Games. Personal Computer.

———. 2009. *Faunasphere*. Big Fish Games. Web.

BioWare. 2009. *Dragon Age: Origins*. Electronic Arts. Personal Computer.

Blizzard Entertainment. 1996. *Diablo*. Blizzard Entertainment. Personal Computer.

———. 2004. *World of Warcraft*. Blizzard Entertainment. Personal Computer.

CCP. 2003. *EVE Online*. CCP. Personal Computer.

Curtis, Pavel. 1990. *LambdaMOO*. Pavel Curtis. Personal Computer.

Cyan Worlds. 1993. *Myst*. Broderbund. Macintosh.

———. 2003. *Uru: Ages beyond Myst*. Ubisoft. Personal Computer.

Destination Games. 2008. *Tabula Rasa*. NC Soft. 2007. Personal Computer.

eGenesis. 2003. *A Tale in the Desert*. eGenesis. Personal Computer.

Game Lab. 2003. *Diner Dash*. PlayFirst. Personal Computer.

Gygax, Gary, and Dave Arneson. 1974. *Dungeons & Dragons*. Tactical Studies Rules. Pen and Paper RPG.

Linden Lab. 2003. *Second Life*. Linden Lab. Personal Computer.

Lucasfilm Games. 1986. *Habitat*. Quantum Link. Commodore 64.

Maxis. 1989. *SimCity*. Maxis. Personal Computer.

Monolith Productions. 2005. *The Matrix Online*. Warner Bros. Interactive Entertainment. Personal Computer.

MPS Labs. 1990. *Sid Meier's Civilization*. MicroProse. Personal Computer.

Nintendo. 1981. *Donkey Kong*. Nintendo. Arcade.

———. 1985. *Super Mario Bros*. Nintendo. Nintendo Entertainment System (NES).

———. 1987. *The Legend of Zelda*. Nintendo. Nintendo Entertainment System (NES).

———. 2005. *Nintendogs*. Nintendo. Nintendo DS.

Origin Systems. 1997. *Ultima Online*. Electronic Arts. Personal Computer.

Playdom, Inc. 2010. *Social City*. Playdom, Inc. Facebook.

PopTop Software. 1998. *Railroad Tycoon II*. Gathering of Developers. Personal Computer.

Sony Online Entertainment. 2003. *Star Wars Galaxies: An Empire Divided*. Lucas Arts. Personal Computer.

———. 2004. *EverQuest 2*. Sony Online Entertainment. Personal Computer.

Sulake Corporation. 2000. *Habbo Hotel*. Sulake Corporation. Web.

There. 2003. There.com. There. Web.

Three Rings. 2003. *Yohoho! Puzzle Pirates*. Three Rings. Web.

Tiny Speck. 2011. *Glitch*. Tiny Speck. Web.

Turbine, Inc. 1999. *Asheron's Call*. Microsoft Game Studies. Personal Computer.

———. 2006. *Dungeons & Dragons Online*. Warner Bros. Personal Computer.

———. 2007. *The Lord of the Rings Online*. Turbine, Inc. and Midway Games. Personal Computer.

Verant Interactive. 1999. *EverQuest*. Sony Online Entertainment. Personal Computer.

Westwood Studios. 2002. *Earth & Beyond*. Electronic Arts. Personal Computer.

Wizet. 2005. *Maple Story*. Nexon America Inc. Web.

Zynga. 2009. *FarmVille*. Zynga. Facebook.

———. 2009. *Mafia Wars*. Zynga. Facebook.

———. 2010. *FrontierVille*. Zynga. Facebook.

Allison, Anne. 2006. *Millennial Monsters: Japanese Toys and the Global Imagination*. Los Angeles: University of California Press.

Bartle, Richard. 1996. "Hearts, Clubs, Diamonds, Spades: Players Who Suit MUDS." Available online at http://www.mud.co.uk/richard/hcds.htm.

———. 2014. "Design Principles: Use and Misuse." In *Multiplayer: The Social Aspects of Digital Gaming*, ed. Thorsten Quandt and Sonja Kroger, 10–23. Oxon: Routledge.

Begy, Jason, and Mia Consalvo. 2011. "Achievements, Motivations, and Rewards in *Faunasphere*." *Game Studies* 11, no. 1. Available online at http://gamestudies.org/1101/articles/begy_consalvo.

Big Fish Games. 2011. "About Us." Available online at http://pressroom.bigfishgames.com/about.asp.

Bloch, Linda-René, and Dafna Lemish. 1999. "Disposable Love: The Rise and Fall of a Virtual Pet." *New Media and Society* 1, no. 3: 283–303.

Boellstorf, Tom, Bonnie Nardi, Celia Pearce, and T. L. Taylor. 2012. *Ethnography and Virtual Worlds: A Handbook of Method*. Princeton, N.J.: Princeton University Press.

Bogost, Ian. 2007. *Persuasive Games*. Cambridge, Mass.: MIT Press.

Boudreau, Kelly. 2012. "Between Play and Design: The Emergence of Hybrid-Identity in Single-Player Video Games." PhD diss., Université de Montréal, Canada.

Brown, Stuart. 2009. *Play: How It Shapes the Brain, Opens the Imagination, and Invigorates the Soul*. New York: Penguin.

Carter, Marcus, Martin Gibbs, and Michael Arnold. 2012. "Avatars, Characters, Players and Users: Multiple Identities at/in Play." Proceedings of OzCHI'12, the Twenty-Fourth Australian Computer-Human Interaction Conference, November 26–30, Melbourne, Australia.

Chen, Mark. 2011. *Leet Noobs: The Life and Death of an Expert Player Group in World of Warcraft*. New York: Peter Lang.

Chesney, Thomas, and Shaun Lawson. 2007a. "The Illusion of Love: Does a Virtual Pet Provide the Same Companionship as a Real One?" *Interaction Studies* 8, no. 2: 337–42.

———. 2007b. "The Impact of Owner Age on Companionship with Virtual Pets." Paper presented at the Fifteenth European Conference on Information Systems, June 7–9, St. Gallen, Switzerland.

———. 2008. "Learning to Care for a Real Pet whilst Interacting with a Virtual One? The Educational Value of Games like Nintendogs." Paper presented at the AISB 2008 Convention: Communication, Interaction, and Social Intelligence, April 1–4, Aberdeen, Scotland.

Cleland, Kathy. 2008. "Image Avatars: Self-Other Encounters in a Mediated World." PhD diss., University of Technology, Sydney, Australia.

Consalvo, Mia. 2007. *Cheating: Gaining Advantage in Videogames.* Cambridge, Mass.: MIT Press.

———. 2009. "Hardcore Casual: Game Culture Return(s) to Ravenhearst." Proceedings of the Fourth International Conference on the Foundations of Digital Games, April 26–30, Orlando, Fla. ACM Portal.

———. 2011. "Using Your Friends: Social Mechanics in Social Games." Proceedings of the Sixth International Conference on the Foundations of Digital Games, June 28–July 1, Bordeaux, France. ACM Portal.

Cook, John. 2009. "Big Fish Games Hatches Stealthy Virtual World Faunasphere." *Puget Sound Business Journal,* March 17. Available online at http://www.bizjournals.com/seattle/blog/techflash/2009/03/Big_Fish_creates_virtual_world_Faunasphere_41391087.html.

Delamere, Fern, and Susan Shaw. 2008. "'They See It as a Guy's Game': The Politics of Gender in Digital Games." *Leisure/Loisir* 32, no. 2: 279–302.

Evans, David, Andrei Hagiu, and Richard Schmalensee. 2006. *Invisible Engines: How Software Platforms Drive Innovation and Transform Industries.* Cambridge, Mass.: MIT Press.

Faunasphere Fansite Wiki. 2012. Available online at http://faunasphere.wikispaces.com.

Fine, Gary Alan. 1983. *Shared Fantasy: Role Playing Games as Social Worlds.* Chicago: University of Chicago Press.

Gazard, Alison. 2010. "Player as Parent, Character as Child: Exploring Avatarial Relationships in Gamespace." Proceedings of the Fourteenth International Academic MindTrek Conference: Envisioning Future Media Environments, October 6–8, Tampere, Finland.

Hamilton, Jillian G. 2009. "Identifying with an Avatar: A Multidisciplinary Perspective." Proceedings of the Cumulus Conference: 38° South: Hemispheric Shifts across Learning, Teaching and Research, November 12–14, Swinburne University of Technology and RMIT University, Melbourne, Australia.

Harris, Celia, Helen Patterson, and Richard Kemp. 2008. "Collaborative Recall and Collective Memory: What Happens When We Remember Together?" *Memory* 16, no. 3: 213–30.

Jenkins, Henry. 2006. *Convergence Culture: Where Old and New Media Collide.* New York: New York University Press.

Jenson, Jennifer, and Suzanne de Castell. 2010. "Gender, Simulation and Gaming: Research Review and Redirections." *Simulation & Gaming* 41, no. 1: 51–71.

Juul, Jesper. 2005. *Half Real: Video Games between Real Rules and Fictional Worlds.* Cambridge, Mass.: MIT Press.

———. 2010. *A Casual Revolution: Reinventing Video Games and Their Players.* Cambridge, Mass.: MIT Press.

Kahn, Peter H., Batya Friedman, and Jennifer Hagman. 2002. "'I Care about Him as a Pal': Conceptions of Robotic Pets in Online AIBO Discussion Forums." Paper presented at the CHI 2002 Conference on Human Factors in Computing Systems, April 20–25, Minneapolis, Minn.

Kendall, Lori. 2002. *Hanging Out in a Virtual Pub: Masculinities and Relationships Online.* Berkeley: University of California Press.

Klevjer, Rune. 2006. "What Is the Avatar? Fiction and Embodiment in Avatar-Based Single-Player Computer Games." PhD diss., University of Bergen, Norway.

Kolos, Hillary. 2010. "Not Just in It to Win It: Inclusive Game Play in an MIT Dorm." Master's Thesis, Massachusetts Institute of Technology.

Kucklich, Julian. 2005. "Precarious Playbour: Modders and the Digital Games Industry." *Fibreculture Journal* 5. Available online at http://five.fibreculturejournal.org/fcj-025-precarious-playbour-modders-and-the-digital-games-industry.

Kuittinen, Jussi, Annakaisa Kultima, Johannes Niemela, and Janne Paavilainen. 2007. "Casual Games Discussion." Proceedings of the 2007 Conference on Future Play, November 15–17, Toronto, Canada. ACM Portal.

Kultima, Annakaisa. 2009. "Casual Game Design Values." Proceedings of the Thirteenth Annual International MindTrek Conference: Everyday Life in the Ubiquitous Era, September 30–October 2, Tampere, Finland. ACM Portal.

Lee, Y. H., and D. Y. Wohn. 2012. "Are There Cultural Differences in How We Play? Examining Cultural Effects on Playing Social Network Games." *Computers in Human Behavior* 28, no. 4: 1307–14.

Linderoth, Jonas. 2005. "Animated Game Pieces: Avatars as Roles, Tools, and Props." Paper presented at the Aesthetics of Play Conference, October 14–15, Bergen, Norway.

McCloud, Scott. 1993. *Understanding Comics.* New York: Harper Perennial.

Melson, Gail, Peter H. Kahn, Alan Beck, and Batya Friedman. 2009. "Robotic Pets in Human Lives: Implications for the Human-Animal Bond and for Human Relationships with Personified Technologies." *Journal of Social Issues* 65, no. 3: 547–67.

Meretzky, Steve. 2010. "The Business of Social Games." Paper presented at the MIT Sloan Inaugural Business in Gaming Conference, Cambridge, Mass.

Miller, Greg. 2010. "How Our Brains Make Memories." *Smithsonian Magazine*, May. Available online at http://www.smithsonianmag.com/science-nature/How -Our-Brains-Make-Memories.html.

Mival, Oli, Stewart Cringean, and David Benyon. 2004. "Personification Technologies: Developing Artificial Companions for Older People." Paper presented at the CHI 2004 Conference on Human Factors in Computing Systems, April 24–29, Vienna, Austria.

Montfort, Nick, and Ian Bogost. 2009. *Racing the Beam*. Cambridge, Mass.: MIT Press.

Murray, Janet. 1997. *Hamlet on the Holodeck*. Cambridge, Mass.: MIT Press.

Nardi, Bonnie. 2010. *My Life as a Night-Elf Priest: An Anthropological Account of World of Warcraft*. Ann Arbor: University of Michigan Press.

Newman, James. 2002. "The Myth of the Ergodic Videogame: Some Thoughts on Player-Character Relationships in Videogames." *Game Studies* 2, no. 1. Available online at http://gamestudies.org/0102/newman.

Olick, Jeffrey. 1999. "Collective Memory: The Two Cultures." *Sociological Theory* 17, no. 3: 333–48.

Papargyris, Anthony, and Angeliki Poulymenakou. 2009. "The Constitution of Collective Memory in Virtual Game Worlds." *Journal of Virtual Worlds Research* 1, no. 3. Available online at http://jvwresearch.org/index.php/past-issues/ 13-cultures-of-virtual-worlds.

Paul, Christopher. 2012. *Wordplay and the Discourse of Video Games: Analyzing Words, Design, and Play*. New York: Routledge.

———. 2013. "Do You Belong Here? Revisiting How EVE Online Welcomes New Players." Proceedings of the Eighth International Conference on the Foundations of Digital Games, May 14–17, Chania, Greece.

Pearce, Celia. 2009. *Communities of Play: Emergent Cultures in Multiplayer Games and Virtual Worlds*. Cambridge, Mass.: MIT Press.

Peterson, John. 2012. *Playing at the World*. San Diego: Unreason.

Pivec, Pual, and Maja Pivec. 2011. "Digital Games: Changing Education, One Raid at a Time." *International Journal of Game-Based Learning* 1, no. 1: 1–18.

Radway, Janice. 1984. *Reading the Romance: Women, Patriarchy and Popular Literature*. Durham: University of North Carolina Press.

Rainier. 2007. "Big Fish Games Acquires Thinglefin." *Worthplaying*, November 28. Available online at http://worthplaying.com/article/2007/11/28/news/ 47042.

Rehak, Bob. 2003. "Playing at Being: Psychoanalysis and the Avatar." In *The Video Game Theory Reader*, ed. Mark J. P. Wolf and Bernard Perron, 103–27. New York: Routledge.

Rossi, Luca. 2009. "Playing Your Network: Gaming in Social Network Sites." Proceedings of DiGRA 2009: Breaking New Ground: Innovation in Games, Play, Practice and Theory, September 1–4, West London, U.K. Available online at http://digra.org:8080/Plone/dl/db/09287.20599.pdf.

Royse, Pamela, Joon Lee, Undrahbuyan Baasanjav, Mark Hopson, and Mia Consalvo. 2007. "Women and Games: Technologies of the Gendered Self." *New Media & Society* 9, no. 4: 555–76.

Salen, Katie, and Eric Zimmerman. 2004. *Rules of Play: Game Design Fundamentals*. Cambridge, Mass.: MIT Press.

Sicart, Miguel. 2011. "Against Procedurality." *Game Studies* 11, no. 3. Available online at http://gamestudies.org/1103/articles/sicart_ap.

Sotamaa, Olli. 2009. "The Player's Game: Towards Understanding Player Production among Computer Game Cultures." PhD diss., University of Tampere, Finland.

Taylor, T. L. 2006. *Play between Worlds: Exploring Online Game Culture*. Cambridge, Mass.: MIT Press.

Taylor, T. L., and Emma Witkowski. 2010. "This Is How We Play It: What a Mega-Lan Can Teach Us about Games." Proceedings of the Fifth International Conference on the Foundations of Digital Games, June 19–21, Monterey, Cal.

Turkle, Sherry. 2011. *Alone Together*. New York: Basic.

Williams, Dmitri, Mia Consalvo, Scott Caplan, and Nick Yee. 2009. "Looking for Gender: Gender Roles and Behaviors among Online Gamers." *Journal of Communication* 59, no. 4: 700–725.

Wohn, D. Y. 2012. "The Role of Habit Strength in Social Network Game Play." *Communication Research Reports* 29, no. 1: 74–79.

Wohn, D. Y., C. Lampe, R. Wash, N. Ellison, and J. Vitak. 2011. "The 'S' in Social Network Games: Initiating, Maintaining, and Enhancing Relationships." Proceedings of the Forty-Fourth Hawaii International Conference on Systems Science, January 4–7, Kauai, Hawaii.

Woodford, Darryl. 2009. "Exploring Agency: Dominant Conceptions of Avatar-Related Game World Control." Master's Thesis, IT University of Copenhagen, Denmark.

Yee, Nick. 2005. "Buying Gold." *Daedalus Project*, October 17. Available online at http://www.nickyee.com/daedalus/archives/001469.php.

———. 2006. "Motivations for Play in Online Games." *Cyberpsychology & Behavior* 9, no. 6: 772–75.

———. 2007. "Likelihood of Quitting." *Daedalus Project*, March 20. Available online at http://www.nickyee.com/daedalus/archives/001557.php.

MIA CONSALVO is professor and Canada Research Chair in game studies and design at Concordia University. She is author of *Cheating: Gaining Advantage in Videogames* and coeditor of *Sports Videogames* and *The Handbook of Internet Studies*.

JASON BEGY is a PhD student in communication studies at Concordia University.